PORTSMOUTH TRANSPORT

From Old Photographs

RON BROWN

AMBERLEY

First published 2010

Amberley Publishing Plc
Cirencester Road, Chalford,
Stroud, Gloucestershire, GL6 8PE

www.amberley-books.com

British Library Cataloguing in Publication Data.
A catalogue record for this book is available from the British Library.

ISBN 978 1 4456 0136 6

Typesetting and Origination by FONTHILLDESIGN.
Printed in the UK.

Contents

Acknowledgements

The author wishes to thank all those who have contributed to the compilation of this book. Most of the pictures are from my own collection, but I am also indebted for additional photographic material from the *Portsmouth News*, Alf Harris, John Faulkner, Chris Davies, Morrie Hanson, Peter Bennett, Barbara Brown, Ron Plater, R. Thompson, George Childs, Angela Bushell, Peter Stevens, L. Ricketts, Frank Holt, the late David Fereday Glenn, Gordon Chatburn, Brian Oakley, R. E. New, Alan Crockford, Wally Greer, Ted Saunders, T. J. Gardener. Apologies to anyone that I have inadvertently omitted.

Bibliography

Gosport Transports by Ron Brown 1982.
Tramways of Portsmouth by S. E. Harrison 1963.
A Royal Road by Sam Fay 1889.
Solent Passages and Steamers by Ken Davies.
Portsmouth Airport by Anthony Triggs 2002.
Portsmouth's Tramways by Martin Petch 1996.
Railway Heritage Portsmouth by Harvey & Rooke 1997.
Southern Railway 1923-1947 by E. J. Rose 1996.
Fares Please by Eric Watts 1987.
'Nostalgia articles and columns' by Ron Brown 1996-2006, for the *Portsmouth News*.
Roads, Rails & Ferries of Solent Area by D. Fereday Glenn 1980.

About the Author

Having produced twenty-three books and hundreds of local newspaper articles and columns, Ron Brown will need no introduction to local history enthusiasts. His work other than history includes *Georgia On My Mind –The Nat Gonella Story* 1985 and the sequel *Nat Gonella – A Life in Jazz* 2005. This latest book, *Portsmouth's Transport*, is the perfect companion to two other books he has produced for Amberley Publishing in 2009, *The Pubs of Portsmouth* and *The Cinemas & Theatres of Portsmouth*.

Introduction

Of all the subjects that are embraced by the sentimental longing for the past that we refer to as nostalgia, transports of yesteryear must rate high on the list of the most popular, and I feel that many readers and enthusiasts would agree that the various transport modes we have today do not possess the character or charisma of their predecessors, whether it be by road, rail, sea or air travel.

The more mature individual such as myself may impart some degree of regret or sadness for the generations that supersede us that have never experienced the thrill of travelling on a steam train, lurching through the streets on an electric tram, who have not desperately clung to the rail of a ferryboat as it bobbed up and down alarmingly, or flown in a plane in which the seats are more like deckchairs. Okay, I have to agree that transport today is a darn sight more comfortable to travel on, but it's certainly not so interesting or adventurous.

In times past, Portsmouth enjoyed the presence of most of the various means of public transport, and unlike other large cities in Britain that are landlocked, being an island, Portsmouth also had the addition of water transport. It is still well-served by ferries across the harbour, to the Isle of Wight and even further to the Continent. Sadly, anyone under the age of fifty has never experienced the delight of crossing the harbour between Portsmouth and Gosport on the old chain ferry, for it ceased operating in 1959, thus forcing motorists to travel 15 miles by road to reach the same point either side of the harbour. This, of course, being before the M27 and M275 motorways were introduced in 1976, although the vast increase in vehicular traffic and entering these highways has periodically encouraged some residents to call for the return of the vehicle carrying chain ferry across the harbour. However, like other plans to build a tunnel under the harbour, this has proved impracticable and unaffordable.

Electric trams and trolleybuses are still remembered fondly by many older residents, especially the latter, for they were quiet-running, smooth and comfortable, and eco-friendly. The main drawback to trams and trolleybuses is that they were restricted by tracks and overhead lines, and therefore not as flexible road wise as the motor buses that superseded them.

Generations of Portsmouth folk today do not realise that Portsmouth once had its own airport, a venture that ceased operating in 1973 having flourished for 41 years. Surprisingly, Portsmouth Airport was never a 'white elephant' and made an average profit of £2,000 a year, not great but never in the red.

Over the following pages many aspects of Portsmouth travel are featured, from ferryboats, bicycles and trams to buses, trains and aircraft. To my knowledge, no other literary publication has included such a wide and varied selection of transport centred solely on Portsmouth. However, one has to consider that this work is primarily pictorial and therefore historical data is restricted to accompanying captions, but nevertheless the author sincerely hopes that it will provide some measure of nostalgic pleasure for the reader and they feel it worthy to add to their bookshelves.

Ron Brown

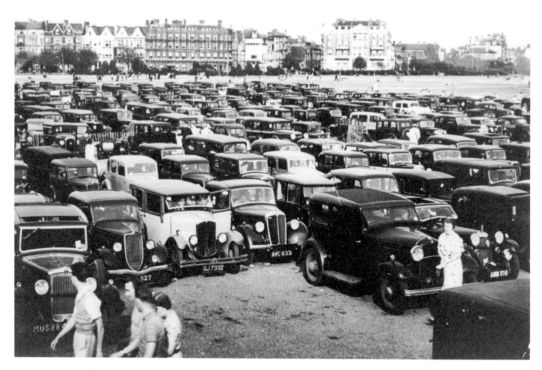

So you think we have traffic problems today? The 'Car Park Full' signs were in force on Southsea Common in the 1930s.

On the Waterfront

With its spectacular view of the harbour and the many types of shipping that enters it, from pleasure yachts and ferryboats to naval warships and huge Continental ferries, Portsmouth's waterfront has always provided the onlooker with a wealth of interest. It is an ever-changing scene, especially in more recent times with the addition of the Gunwharf Quays development and the striking Spinnaker Tower with its magnificent views over the area. However, this book concerns the past so this section is dedicated to providing a reminder of the harbour and vessels from days long gone.

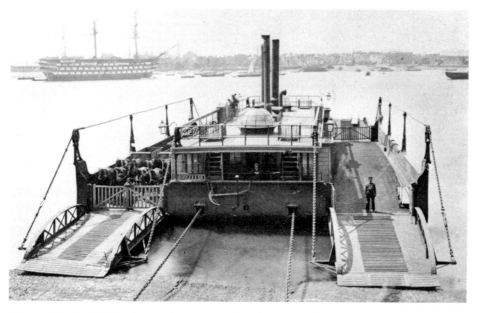

The much-missed chain ferry, referred to as the *Floating Bridge* by local folk that traversed the harbour to link Portsmouth and Gosport. The ferry is pictured above on the Portsmouth side at the end of Broad Street in Old Portsmouth, *c.* 1900.

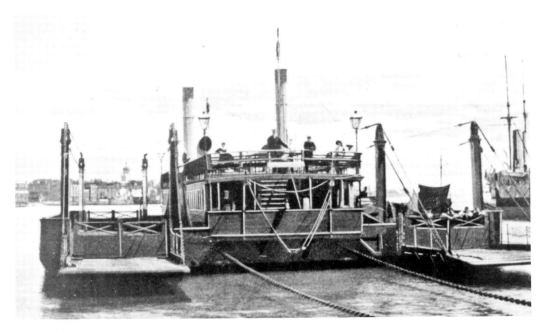

Above: The Portsmouth-Gosport chain ferry, seen here on the Gosport side. This service began operating in 1840; the first bridge was the 100 ft long by 60 ft wide *Victoria*, which was propelled by two steam engines running on chains. It proved so popular that another vessel, the *Albert*, was added in 1842.

Below: The ferry terminal in Broad Street from the harbour, *c.* 1900.

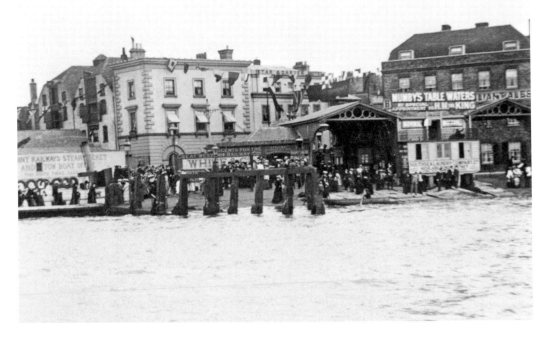

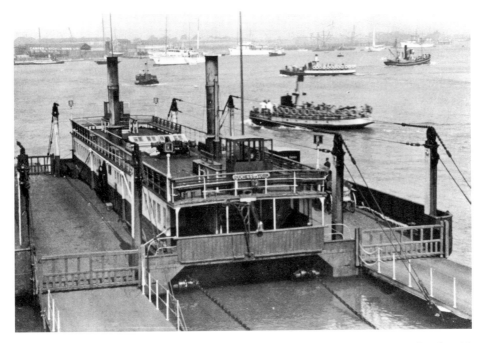

Above: A fine view of the *Duchess of York* floating bridge from the Portsmouth side with a Gosport ferry boat passing in the background.

Below: This early 1900s picture features a floating bridge at the centre, a Gosport ferryboat on the extreme left, and a horse tram at the bottom of the photograph. The wooden warship top right is the HMS *St. Vincent* training ship.

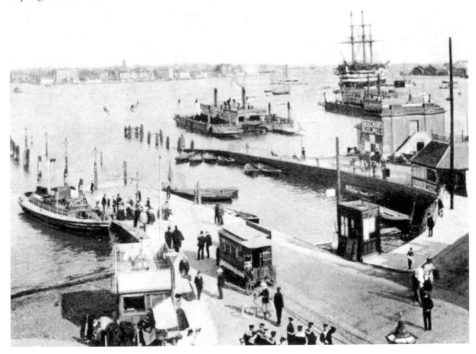

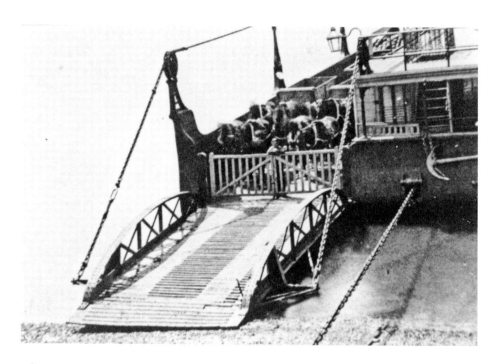

Above: A floating bridge transporting cattle across the harbour, it also carried carts, cars and lorries. Through its 119 year service there were only four bridges, the *Victoria*, *Albert*, *Alexandra* and the *Duchess of York*.

Below: The last floating bridge moored at Gosport shortly before the service ceased in 1959, leaving motor transport to drive 15 miles around the harbour.

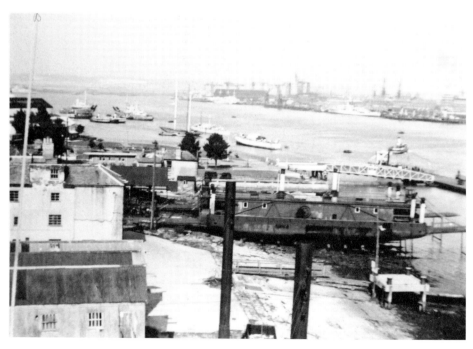

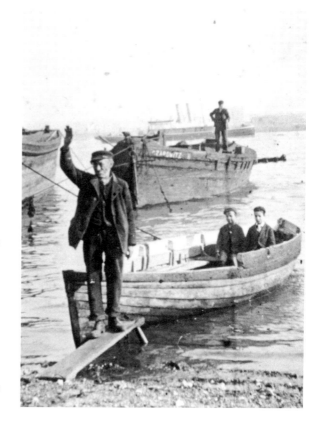

Right: A Portsmouth Harbour waterman touts for business to row passengers around or across the harbour in the 1890s. Young boys were employed to sit in the boats to give the impression that they were getting filled and about to depart.

Below: Many older local folk will have fond memories of crossing the harbour between Portsmouth and Gosport on the old 'V' ferry boats, the boats had such names as the *Vadne*, *Varos*, *Vesta* and *Vita*. This scene features two ferry boats at the Portsea pontoon in 1905.

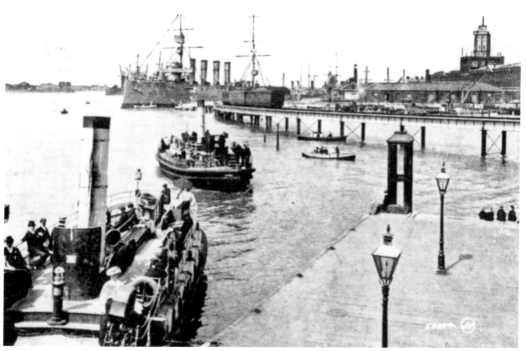

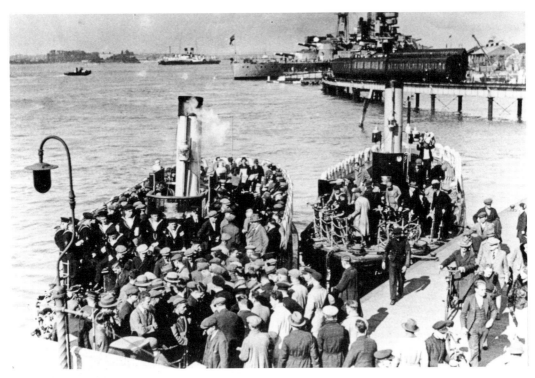

Above: Here we have a good example of the old ferry boats at peak-times when they were jam-packed with dockyard workers and naval men, commuting across the harbour.

Below: The *Ferry Queen* on her harbour trials in 1959 when she was added to the service. Akin to several of the other ferry boats, the *Ferry Queen* was built locally at Camper & Nicholson's boatyard.

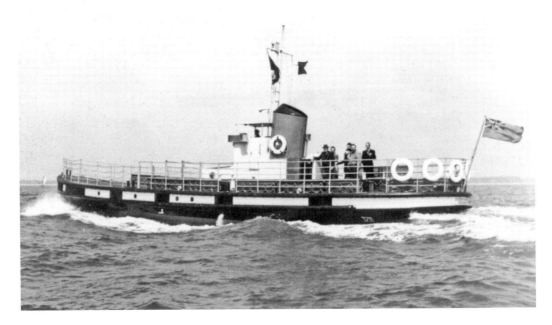

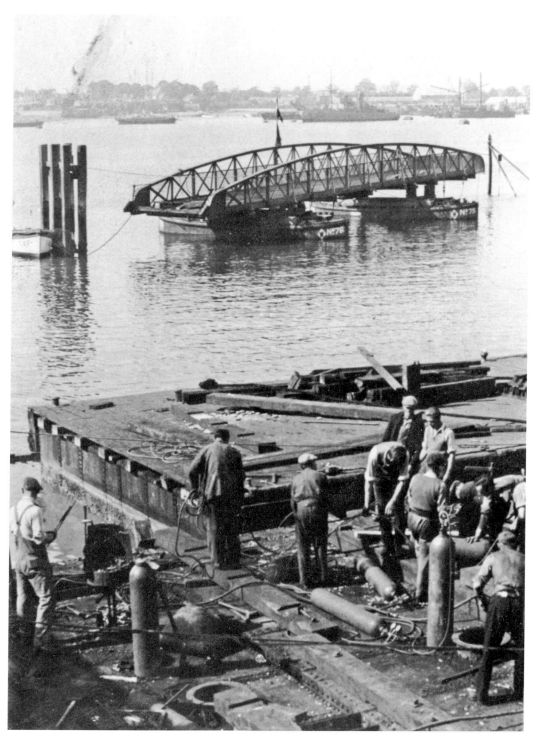

The ferry pontoon at Portsea, which had been in service for over fifty years, was replaced by a new pontoon in the September of 1948, as seen in this historic photograph. The new pontoon was actually built in Portsmouth Harbour on a base of eight large tanks.

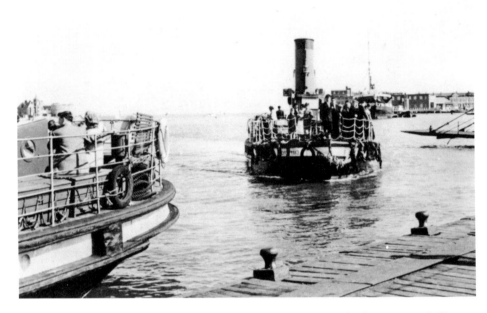

Above: The *Ferry Prince* approaches the Gosport pontoon in the late 1950s. Sailing on these boats was quite an adventure when the sea was rough; while standing at the bow end holding a bicycle, one was liable to receive a soaking.

Below: The old ferry boats were replaced in the mid-1960s by more modern craft such as the *Gosport Queen*, seen below, and the *Portsmouth Queen*, both of which have also been replaced in recent times.

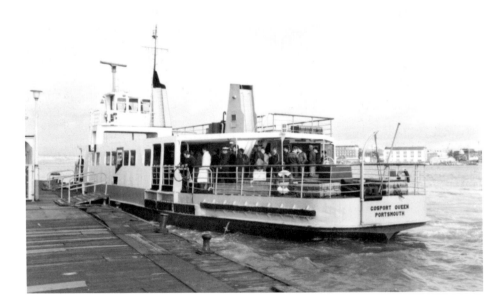

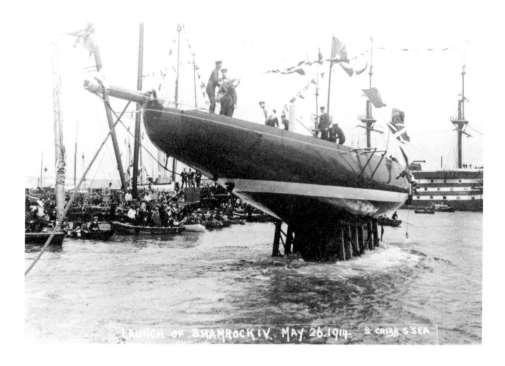

As well as building several harbour ferries, Gosport boat builders Camper & Nicholson also produced many yachts for cruising and racing, their finest hour being the launches of the famous 'Shamrock' and 'Endeavour' class America Cup contenders for Sir Thomas Lipton and Sir Thomas Sopwith. Above we feature the launch of *Shamrock IV* in 1914, and below Sir Tommy Lipton with the yacht's crew at Gosport.

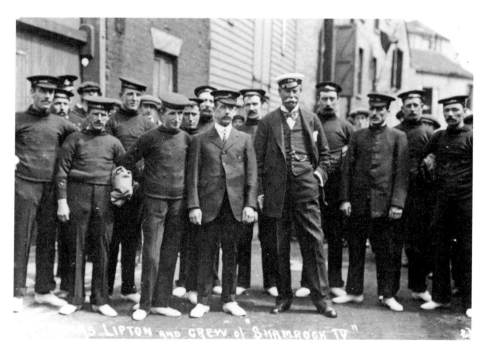

Left: A varied selection of cars and motorcycles wait at the end of Broad Street in the 1920s, prior to boarding an Isle of Wight car ferry at the mouth of the Camber Docks. From 1926 to 1961, the car ferry boats included the MV *Fishbourne*, MV *Hilsea* and MV *Wootton*.

Below: An earlier Isle of Wight car ferry towing service pictured before the outbreak of war in 1914. This service included carrying cattle to the island as well as wheeled vehicles. Fishbourne, at the mouth of Wootton Creek, still serves as the car ferry terminus linking Portsmouth and the Isle of Wight.

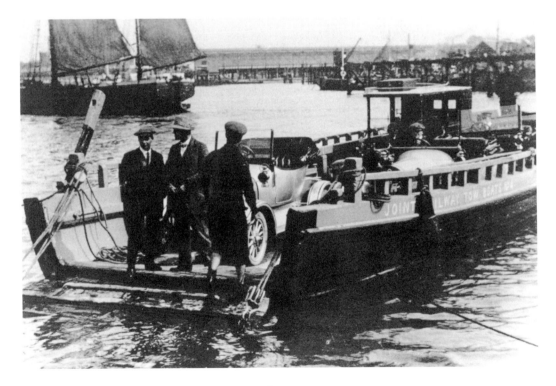

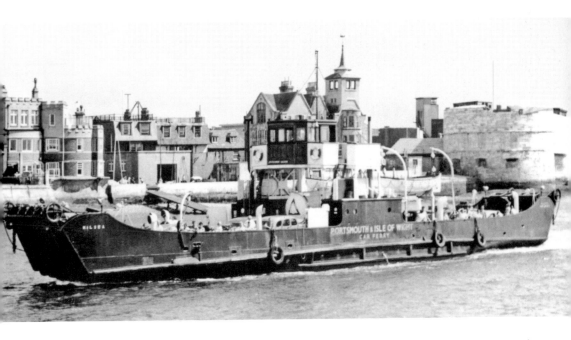

Above: The MV *Hilsea* car ferry passing the Round Tower at the entrance to Portsmouth Harbour. Along with sister boats MV *Fishbourne* and MV *Wootton* this ferry operated the Portsmouth-Fishbourne passage for over 30 years until 1961.

Below: Cars disembarking from a car ferry at Fishbourne, Isle of Wight, in 1959.

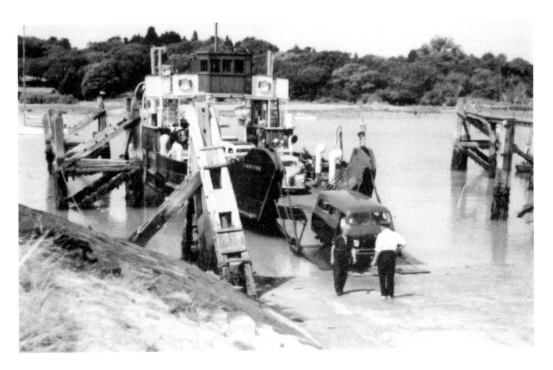

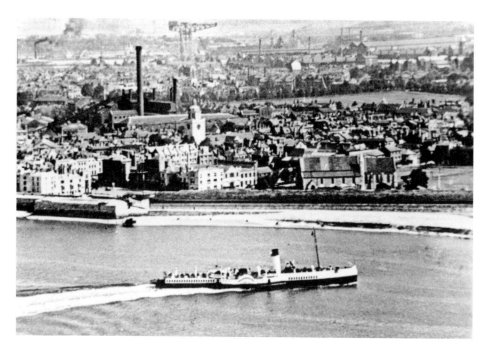

Above: A fine aerial view from the mouth of Portsmouth Harbour in the 1930s, with a paddle steamer sailing out bound for the Isle of Wight.

Below: The steamer *Princess Beatrice* with Isle of Wight passengers boarding from Portsmouth Harbour Pier, *c.* 1910. In those halcyon summers of yesteryear, thousands of trippers and holidaymakers passed through this ferry terminal.

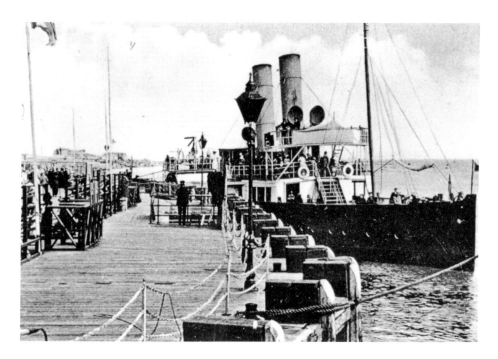

Above: Trippers and holidaymakers embarking on a pleasure steamer at Clarence Pier, Southsea, *c.* 1910.

Below: Because they could accommodate more passengers, boat trips were popular for staff and factory outings in times past. Here we have a happy band of workers about to sail from Portsmouth ferry terminal for the Isle of Wight, with a train in the background.

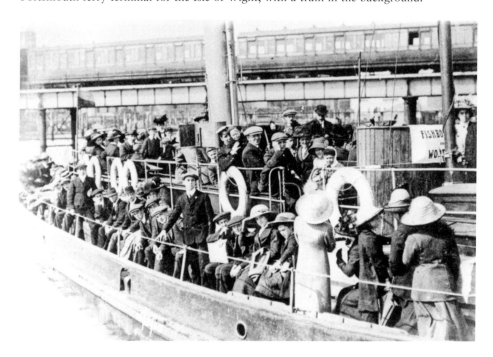

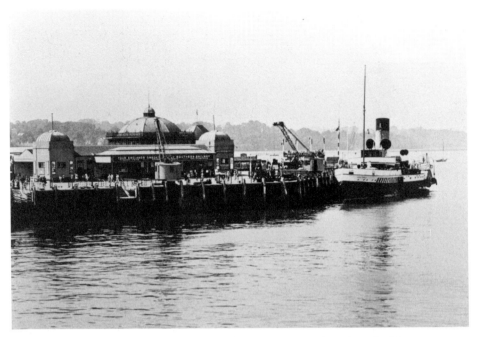

Above: The ferry terminal at the end of Ryde Pier in 1934, where disembarking passengers were met with a large sign proclaiming 'Welcome to England's Garden Isle'. From here, one could board a train which sped down the pier to Ryde and onward to island resorts such as Sandown, Shanklin and Ventnor.

Below: The Southern Railway steamer PS *Sandown* on service.

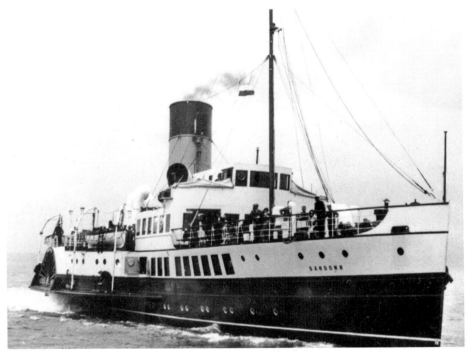

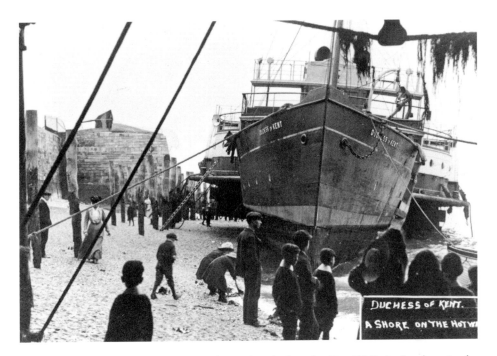

Above and below: The PS *Duchess of Kent* beached at the Hot Walls in Southsea in the September of 1909 after a collision in the Solent. Built in 1897, this paddler survived to be requisitioned for war service by the Royal Navy in 1916, and returned to the Solent crossing until being sold in 1933.

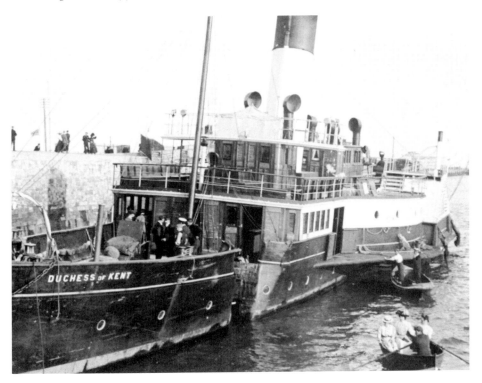

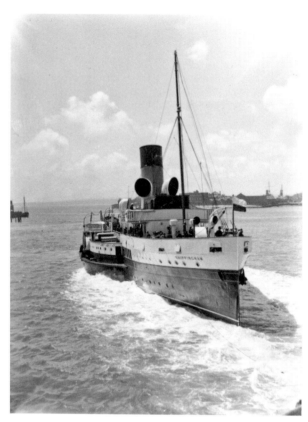

Left: The PS *Whippingham* at the mouth of Portsmouth Harbour. Built in 1930, this paddler saw war service at Dunkirk in 1940 and was subsequently converted into a minesweeper. After the war, she returned to the Solent passage until being sold for scrap in 1963.

Below: The PS *Portsdown* in the 1930s. Built in 1928, this paddle steamer sank in the Solent when she struck a mine in 1941 while *en route* to Ryde from Portsmouth.

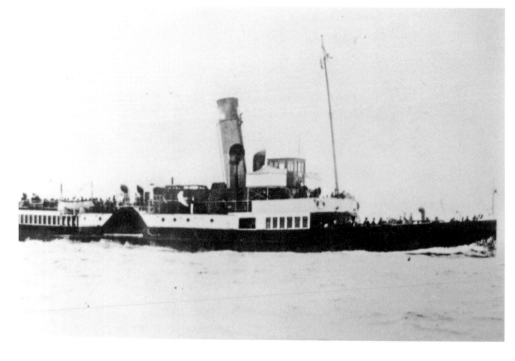

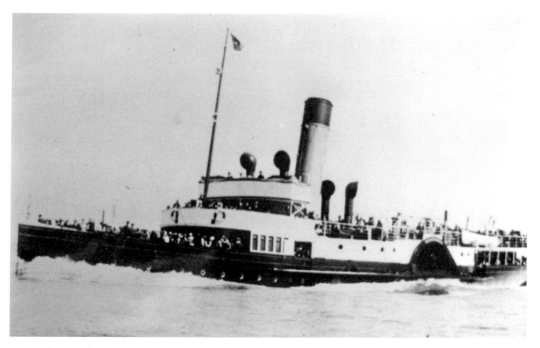

Above: The Southern Railways PS *Shanklin* on the Portsmouth-Ryde passage. Built in 1924, this paddle steamer operated across the Solent until being withdrawn from service in 1950.

Below: The PS *Southsea* which operated the island service from 1930, but was sadly lost in the Second World War when she struck a mine in 1941.

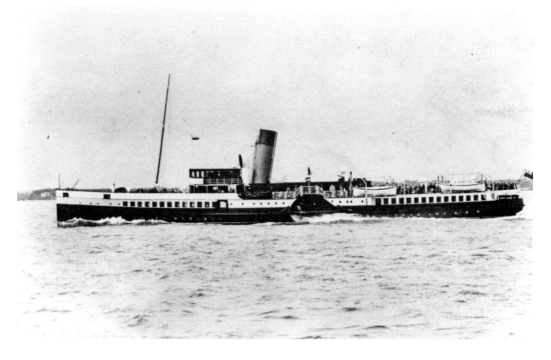

Above and below: Being an island, Portsmouth has Portsmouth Harbour on the west side and Langstone Harbour on the east side. These 1930s photographs feature the Hayling Island ferryboat from the Hayling pontoon in the top picture, and at the Eastney, Portsmouth side in the lower.

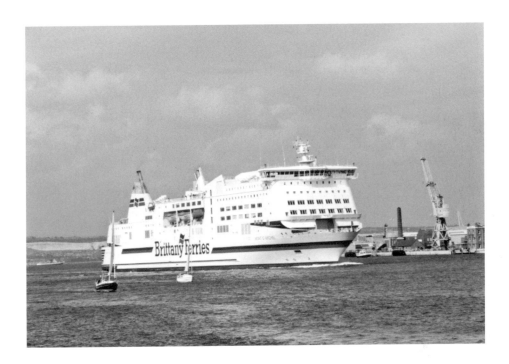

Over many centuries Portsmouth Harbour has provided a grandstand view of a cavalcade of sea-going craft for the bystander, from wooden warships and iron dreadnoughts to submarines and ferryboats. In more recent decades, we have witnessed the presence of the giant continental ferries. In the top photograph, the *Mont St Michel* sails out, while in the lower the *Pride of Cherbourg* enters harbour; both pictures, *c.* 2003.

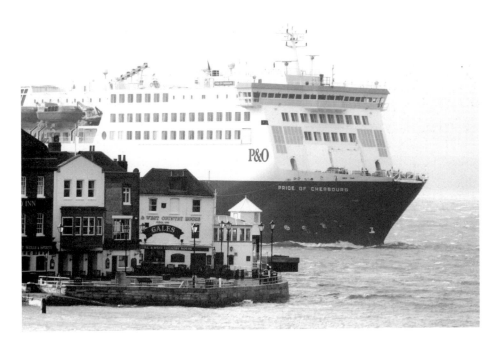

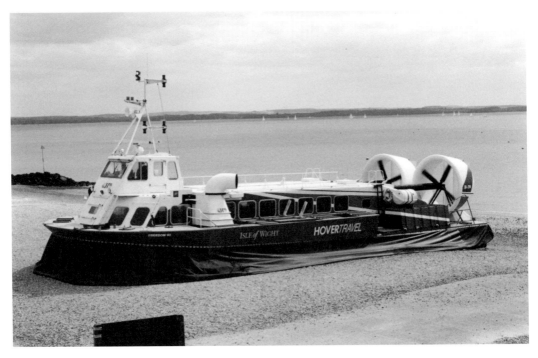

For over forty years a hovercraft service has provided a quick sea passage between Southsea and Ryde, and is still popular with holiday and business visitors travelling to the island. Exhibiting a large and varied number of this craft, Lee-on-the-Solent has the biggest hovercraft museum in Britain. Above we have the Hovertravel *Freedom 90* hover in 2001, and below the Hoverspeed giant *Swift* formerly on the Dover-Calais service.

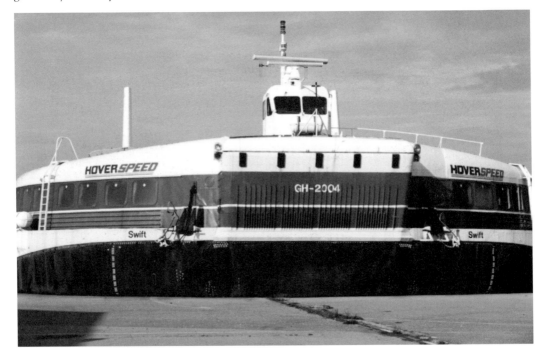

Tramway Cavalcade

The old electric trams are truly an object of pure transport nostalgia; in Portsmouth, they graced our highways for thirty-five years, from 1901 to 1936. Prior to electric trams being introduced, the town was served by horse-drawn trams from 1865. The Portsdown & Horndean Light Railway initiated an electric tram service running north of Cosham and over Portsdown Hill to Horndean in 1903. This transport venture operated for thirty-two years until 1935, but older residents still fondly recall the 'Green cars that went over the hill'.

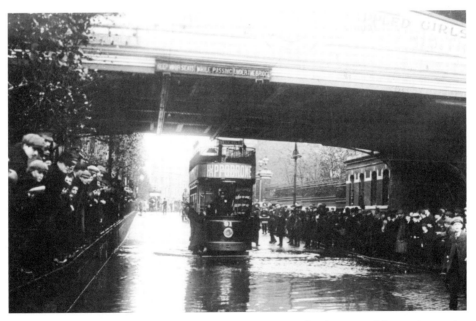

Portsmouth Corporation electric tram No. 91 negotiates flood water while passing under the railway bridge in Commercial Road in 1910. This area was prone to flooding and when trolleybuses were introduced in 1934, the road under the bridge had to be lowered.

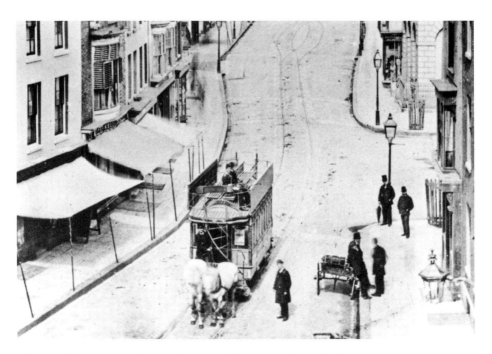

Above: A horse tram in the High Street, Old Portsmouth, in the late 1800s. Horse tramways in Portsmouth commenced operation in 1865, the first route running between the town Railway Station and Clarence Pier at Southsea. By the 1880s, the network had been extended considerably.

Below: A horse car passes under the railway bridge in Commercial Road in the 1890s, with a train passing overhead.

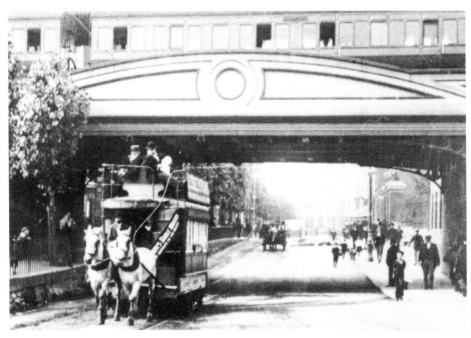

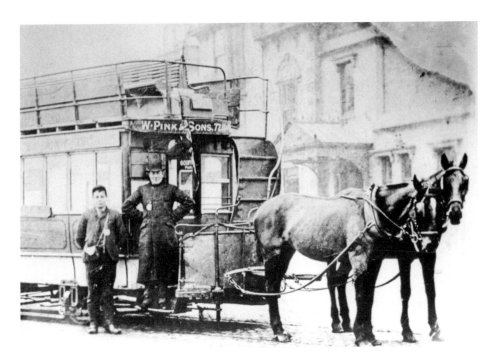

Above: Another 1890s view of a horse tram and crew waiting at the Clarence Pier terminus. By 1901, the horses were replaced by electric trams with routes extending to the town boundaries.

Below: A horse tram passes through the Hilsea Arches, *c.* 1900; the arches were demolished in 1919.

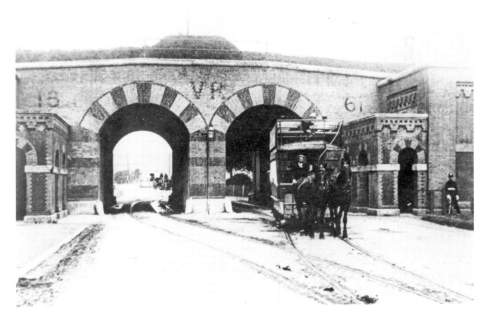

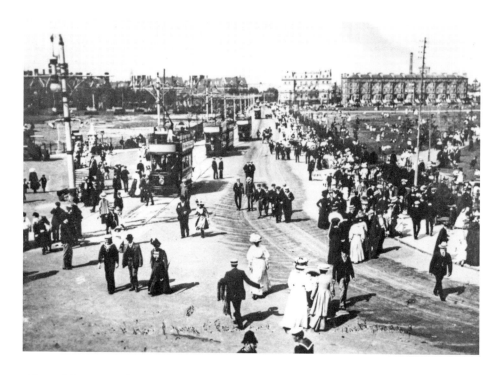

Above: Most certainly captured on a Bank Holiday, a procession of electric trams arriving at the Clarence Pier terminus, *c. 1905.*

Below: Tram No. 43 grinds down Commercial Road; this portion of Commercial Road was converted into a pedestrian precinct some years ago to make it traffic-free.

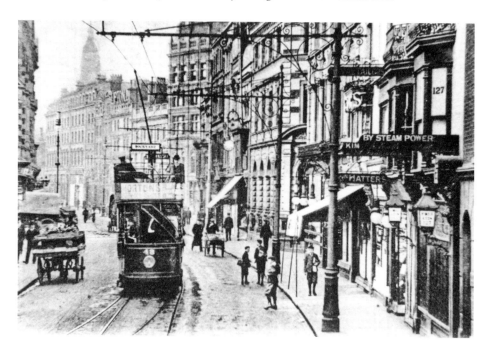

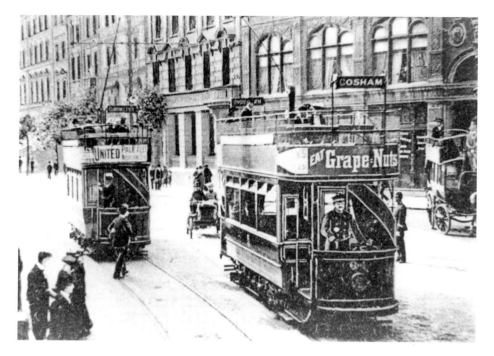

Above: Electric trams pass outside the Central Hotel in Commercial Road, by the Edinburgh Road junction, *c.* 1905. Note the ancient motor car in the middle following the right-hand tram.

Below: Tram No. 18 in Osborne Road, Southsea, in the 1920s. The Queens Hotel is on the right.

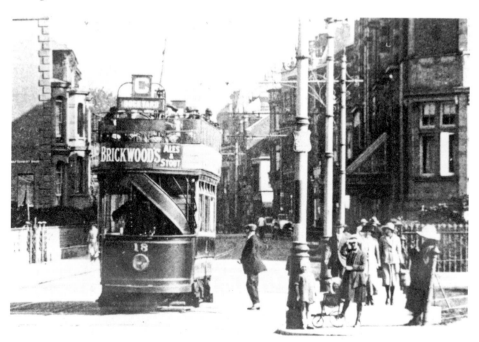

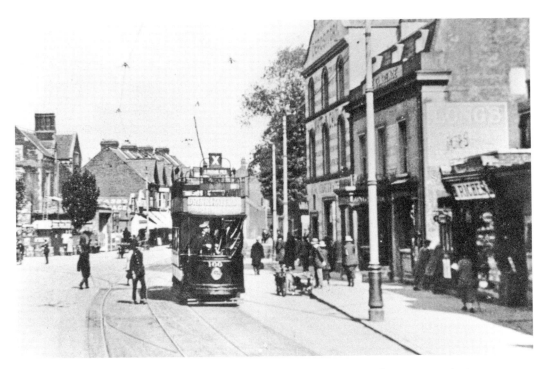

Above: Corporation tram No. 100 glides through North End, Portsmouth, *c.* 1910, on its journey to South Parade Pier, Southsea.

Below: Trams and crews waiting for passengers outside the Portsmouth Guildhall in the 1930s.

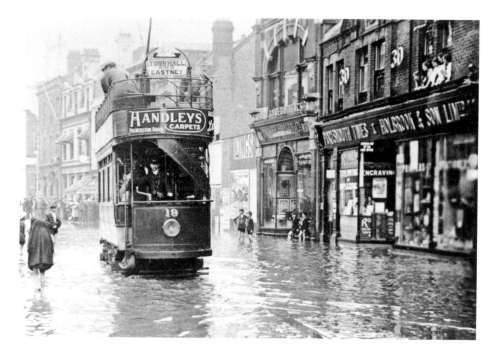

Above: Flood waters were no problem for electric trams, as confirmed in this excellent photograph captured in Commercial Road in the August of 1911. The offices of the *Portsmouth Times* newspaper may be seen on the right.

Below: Around the same period, Tram No. 39 has negotiated the floods to reach its terminal at the end of Broad Street.

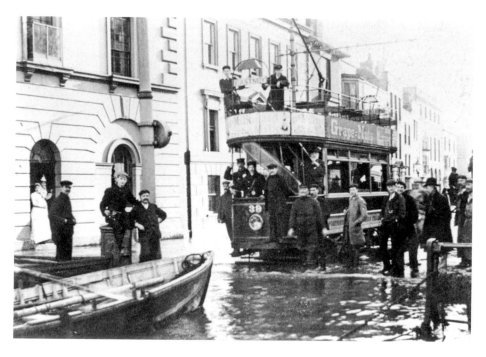

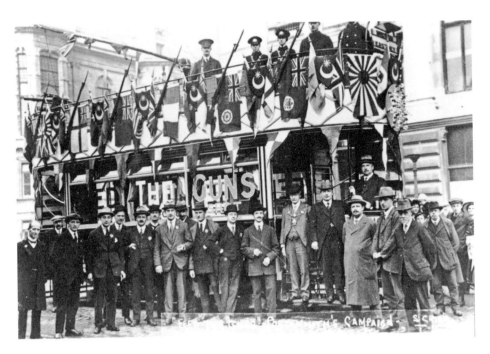

Above: Electric trams proved excellent vehicles by which to advertise a particular event or occasion. Here we have a Portsmouth car patriotically decorated to promote 'Feed The Guns Week' during the First World War.

Below: A tram has been cleverly converted to represent a boat for the 'Portsmouth Navy Week' of 1933. Illuminated at night, such cars looked truly spectacular gliding around the town streets.

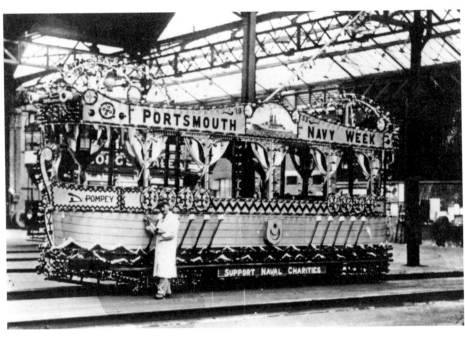

Above: The North End Tram Depot in Gladys Avenue in 1906, which was sited adjacent to the RC Church and school. The tramway system also had another depot at Eastney.

Below: Tramway staff pose proudly for the camera at the North End Depot, and judging by the dignitaries and officials in their resplendent attire, it must have been for a special occasion.

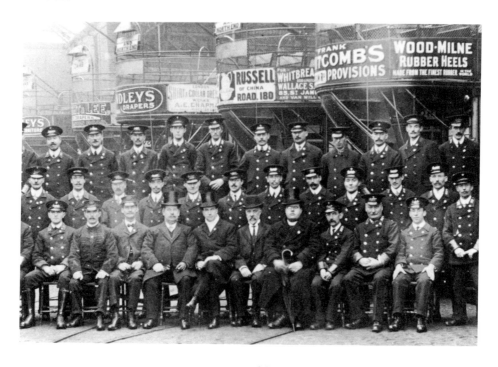

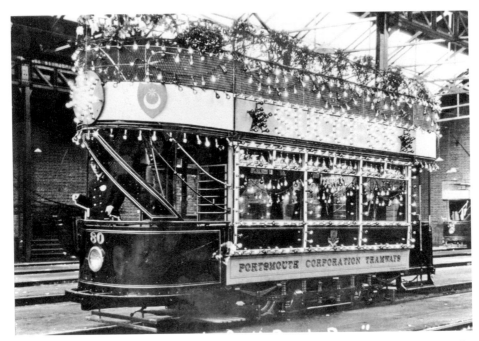

Above: Portsmouth Corporation tram No. 80 decorated and illuminated to promote the newly built South Parade Pier, Southsea, in 1908. The message in lights at the sides of the tram read 'Success to South Parade Pier'.

Below: The Portsmouth Tramways boasted a fine brass band; here we see them posing at North End Depot before a carnival float.

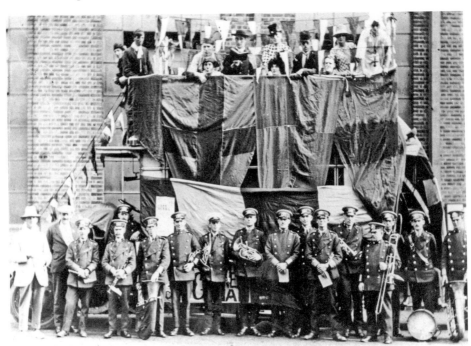

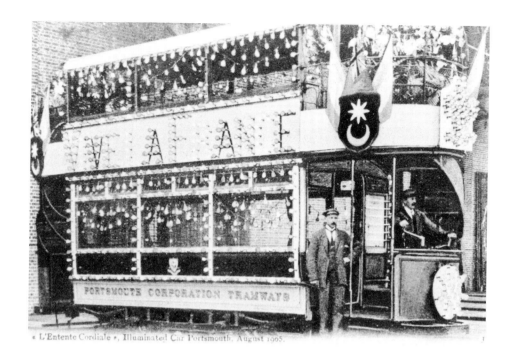

« L'Entente Cordiale », Illuminated Car Portsmouth, August 1905.

Above: A Portsmouth Corporation tram decorated to mark the visit of the French Fleet in the August of 1905.

Below: The Japanese Navy were accorded the same welcome two years later in 1907, on boarding a decorated tram outside the Town Hall.

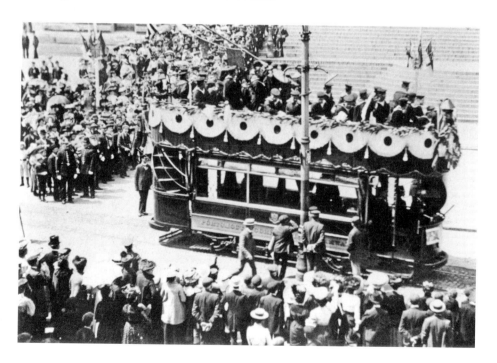

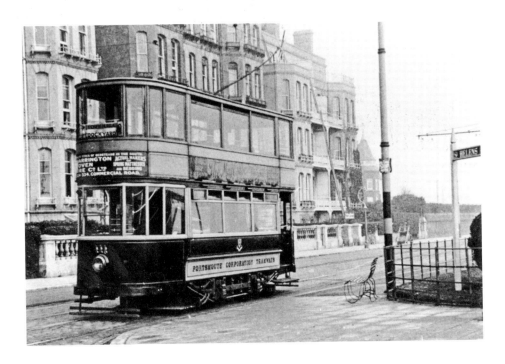

Above: A fine shot of a Portsmouth tram, *c.* 1925, waiting in St. Helen's Parade at Southsea; as this was the terminus, visitors alighted for the nearby South Parade Pier.

Below: Two public transport giants in the form of an electric tram and a motor bus, captured by the pier in front of the Royal Beach Hotel.

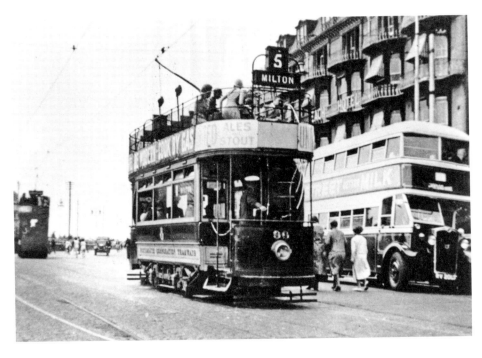

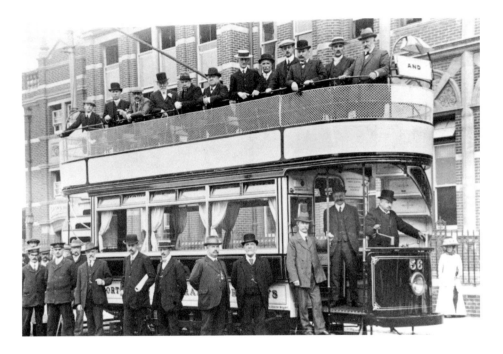

Above: No doubt anticipating an ensuing bun fight at Portsmouth Town Hall, town worthies attend the opening of the Eastney Road Tramways extension on 22 September 1913.

Below: Public transport has always been an excellent means of advertising, as demonstrated on this tram in the Guildhall Square, and it just happens that the gas showroom is nearby.

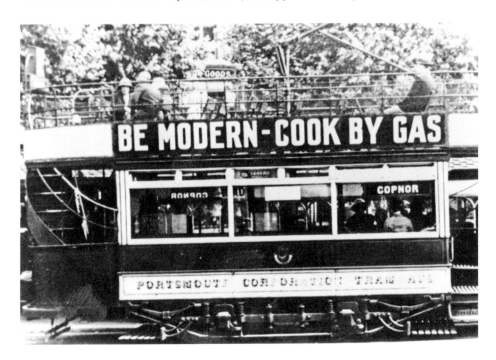

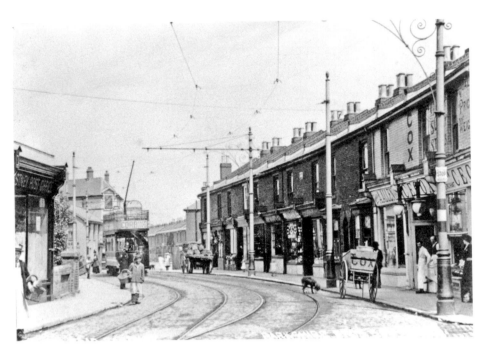

Above: A tram at the Eastney end of Highland Road, Southsea, *c.* 1906. Cox's butcher's shop is on the right on the corner of Eastney Street and Kassassin Street.

Below: Tram No. 13 at Handley's Corner, Southsea, which is a busy junction where Palmerston Road, Osborne Road and Clarendon Road meet. Handley's revered departmental store is currently Debenhams.

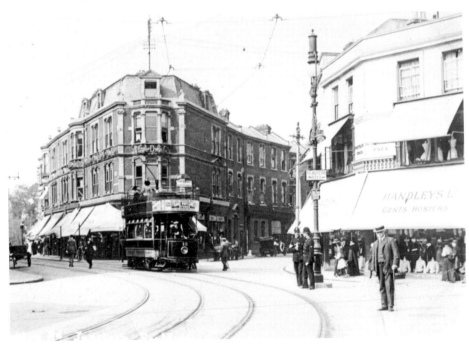

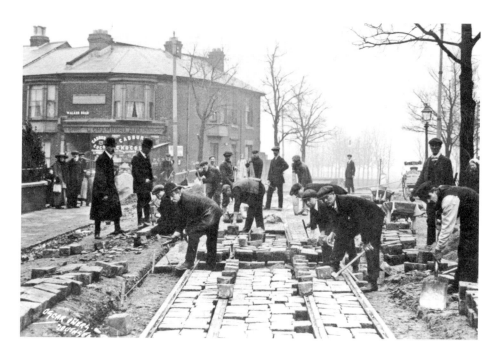

Above: The first of two contrasting scenes, here we see a gang hard at work laying tram tracks in 1913 at the junction of Twyford Avenue and Walker Road, Stamshaw.

Below: A not so happy occasion for tram enthusiasts, with tracks being dug up in London Road, North End, during the Second World War, to obtain metal for the war effort.

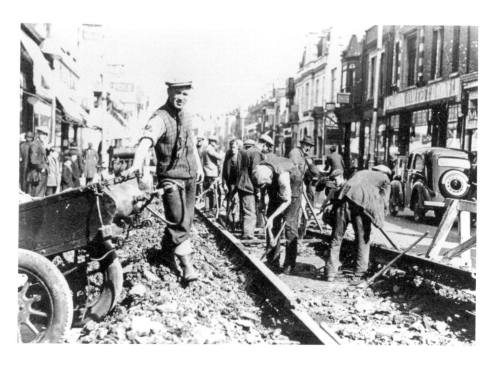

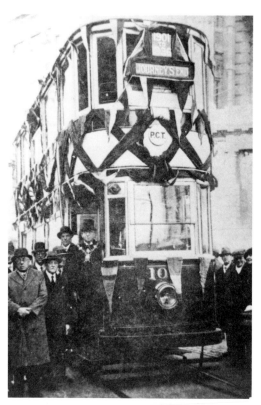

Left: On 10 November 1936, Portsmouth bid a sad farewell to grand old electric trams, with car No. 106 bearing the destination 'Journey's End' to convey city dignitaries to the depot at Eastney. The Portsdown and Horndean tramways service ceased operating in 1935.

Below: Having provided a great service for thirty-five years, the last electric trams pass through the Guildhall Square draped in black mourning garb, as the tramways band played funereal music. Portsmouth trams were replaced by electric trolleybuses.

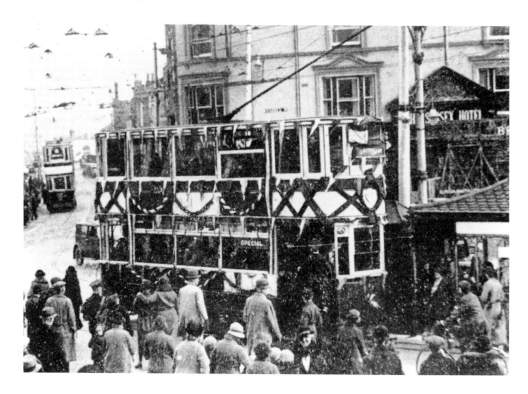

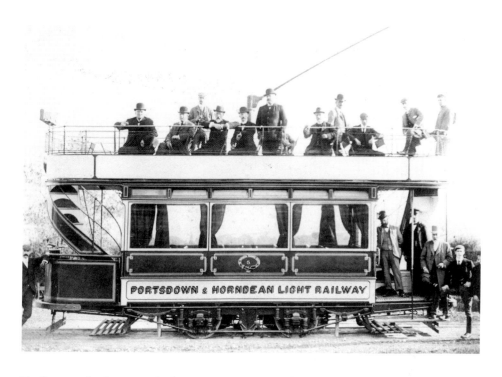

Until 1903, the Portsmouth electric trams terminated at Cosham, but from 2 March that year, passengers were able to travel between Cosham and Horndean in the north via Portsdown & Horndean Light Railway trams. Above we see dignitaries aboard Car No. 5 at the official opening of the P & HLR, in 1903. Below we feature Car No. 6 waiting at Cosham.

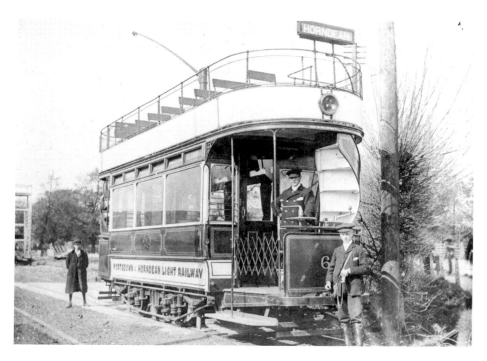

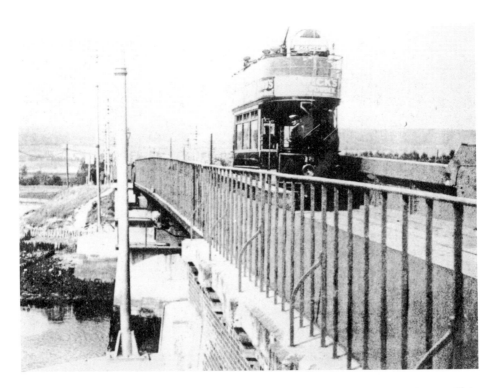

Above: An electric tram grinds its way over a bridge at Cosham with Portsdown Hill in the background. In the early days, passengers wishing to travel further north had to change from Portsmouth Corporation to P & HLR trams at Cosham, but in 1924, a through service commenced between Horndean and Portsmouth Town Hall Square, where below we see Car No. 3 waiting.

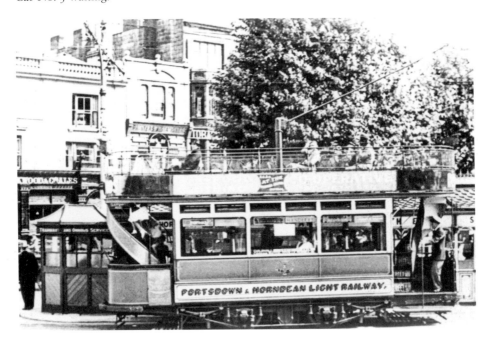

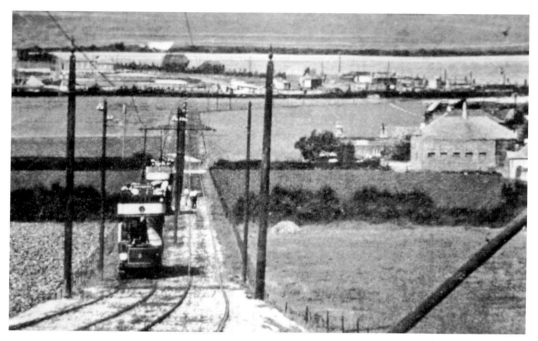

Above: A wonderful view of the P & HLR tracks looking north towards Portsdown from the bridge over the railway at Cosham.

Below: Car No. 10 at the top of the hill as it passes the renowned Belle-Vue Tea Gardens, when it was in the hands of the Jones family.

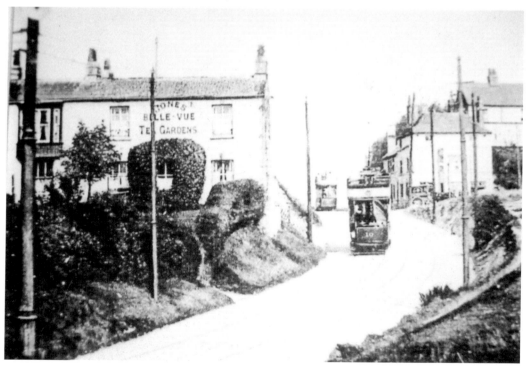

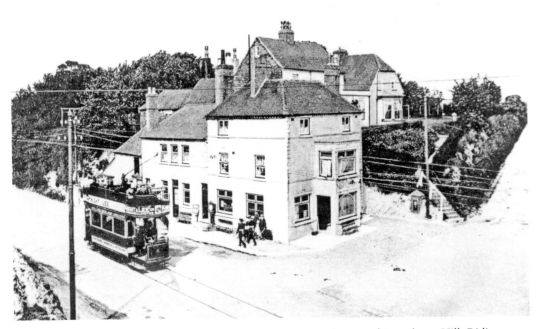

Above and below: P & HLR trams at the George Inn stop at the top of Portsdown Hill. Riding on the top of a tram down the steep hill to Cosham was indeed a hair-raising experience, it was a thrill-a-minute ride only surpassed by the Big Dipper at Blackpool, although the scenic view over Portsmouth was truly magnificent.

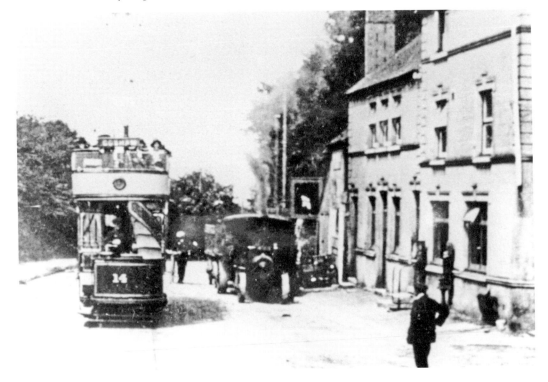

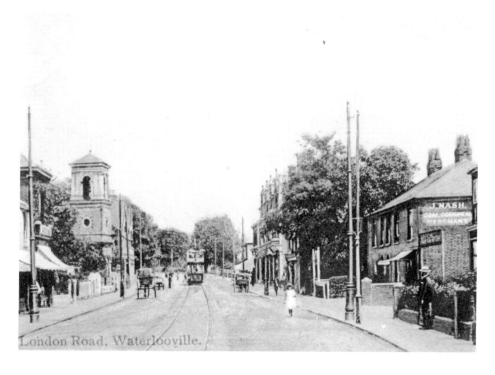

Both views of the Cosham-Horndean tram route were captured in London Road, Waterlooville, *c.* 1910; the top was taken looking north to Horndean and the lower photograph looking south. In more recent times, the centre of Waterlooville was pedestrianised and the London Road by-passed to facilitate this alteration.

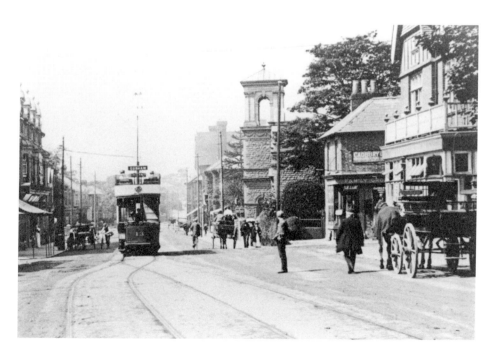

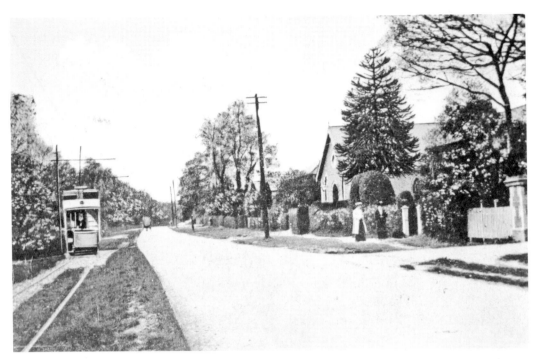

Above: A solitary P & HLR tram at Cowplain, this then rather countrified route linked several villages and hamlets between Cosham and Horndean.

Below: A similar view at Cowplain in Edwardian years; running at the side of the road the tracks left horse-drawn traffic at this spot with a relatively clear central passage.

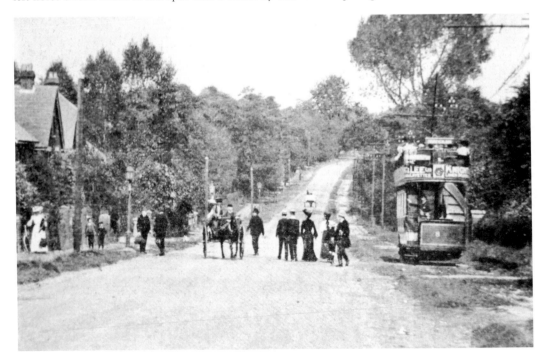

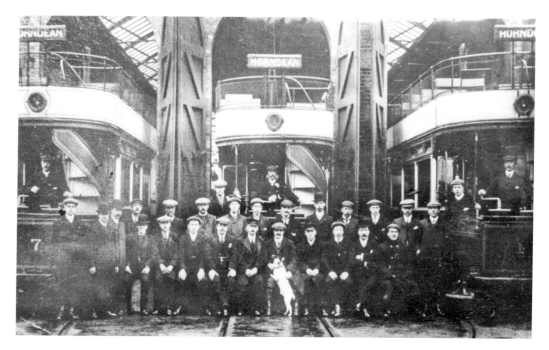

Above: Portsdown & Horndean Light Railway staff pose for a photograph at the Cowplain tram depot.

Below: Car No. 5 waiting for passengers at the Horndean terminus. This wonderful tram service ceased in the mid-1930s to be replaced by Southdown motor buses, and the last green tramcar left Cosham on 9 January 1935.

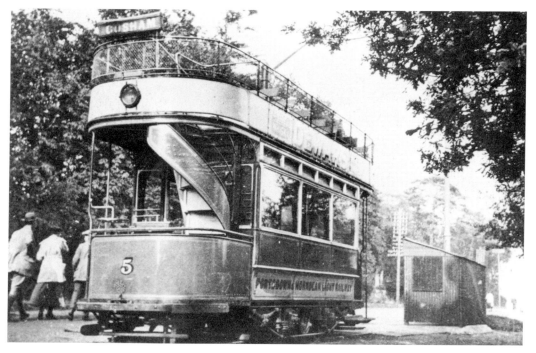

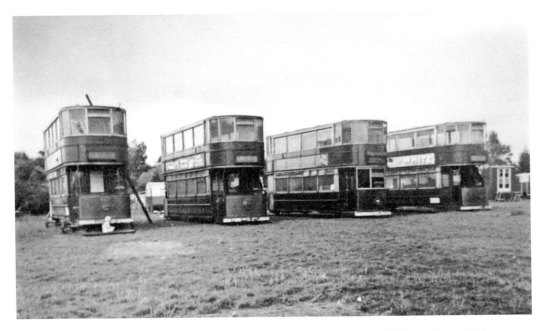

Above: A holiday camp for old trams? This photograph was taken at Fisher's Camp, Fishery Lane, Hayling Island, in 1946.

Below: After the demise of electric trams, many car bodies were sold cheaply and used as garden sheds, but P & HLR Car No. 13 was rescued by enthusiasts and can be seen here being restored at the former Preserved Transport Depot in Old Portsmouth in 1998.

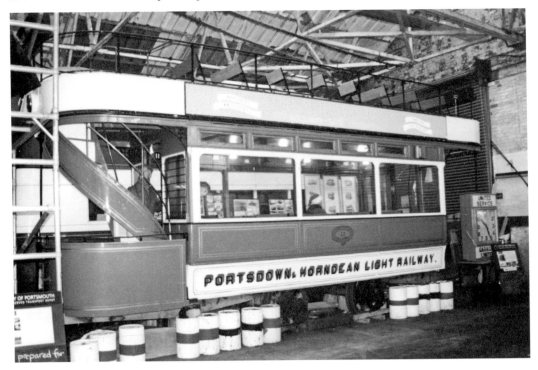

Two-wheeled Wonders

In the affluent times we now live in, young men and women appear to begin motoring in 4-wheeled cars right from the start, but in earlier days of youth many of us could only dream of acquiring a 2-wheeled pedal bicycle, and perhaps later attain the exalted point of owning a motorbike. Like Oxford and Cambridge, Portsmouth could be classed as 'a bicycle town' through the presence of its huge number of Dockyard workers.

Arthur Abbott, a member of the Portsmouth Cycling Club in the early 1900s. Being 6 ft 3 in tall, Arthur must have had his saddle raised considerably.

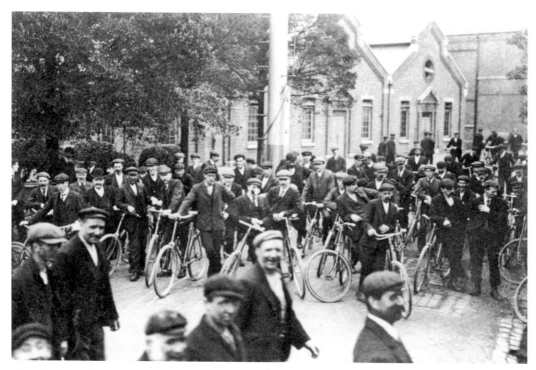

'The Charge Of The Bicycle Brigade'! The highlight of the day for a Portsmouth dockyard worker was the sounding of the 'Going home' hooter; this was the signal for hundreds of bikes to throng the city streets. The top photograph is dated *c.* 1910, while the lower was taken in the 1950s.

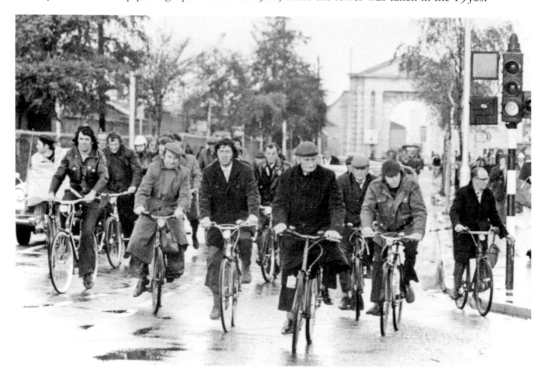

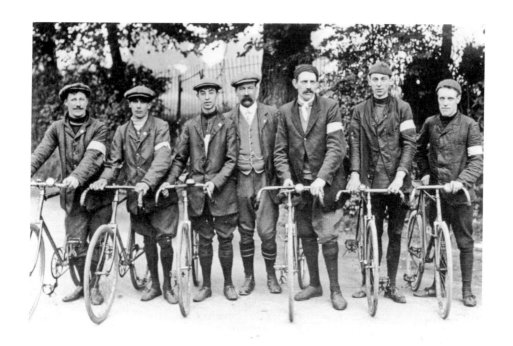

Above: The 'Magnificent Seven' ride again. Members of the Portsea Cycling Club in 1906; this club had their headquarters at the 'Golden Sceptre' pub in Ordnance Row.

Below: Some cyclists could afford three wheels; here we have the Southsea Tricycle Club on Southsea Common in 1888.

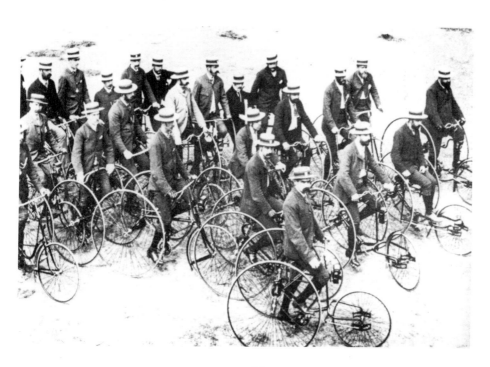

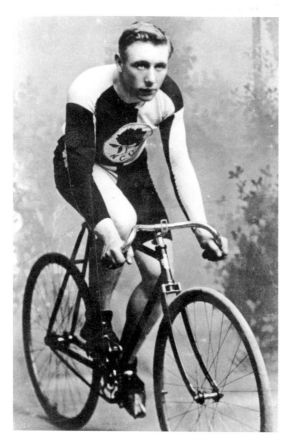

Left: Clarrie Kingsbury, Portsmouth's most famous cyclist, who won a gold medal in the 1908 Olympics. He also ran a cycle shop in Stamshaw.

Below: Cycle racing in times past was very popular at the Alexandra Park track in Portsmouth. This action shot shows a racer named Bailey winning the 1 mile race in 1909.

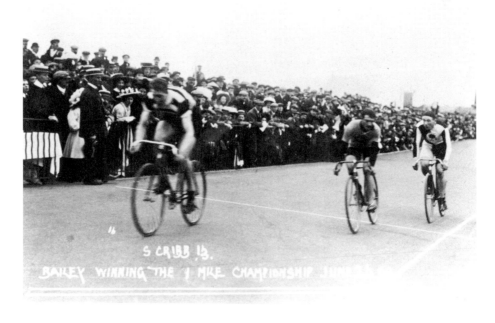

S CRIBB 13.
BAILEY WINNING THE 1 MILE CHAMPIONSHIP

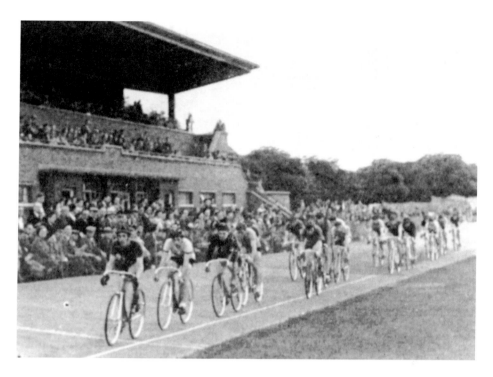

Above: Another cycle racing photograph taken at the Alexandra Park track before a large crowd of spectators.

Below: Action shot featuring a Cyclists *v.* Harriers race at the top of Portsdown Hill in 1930; the result is unknown, but the cyclists must have been strong favourites.

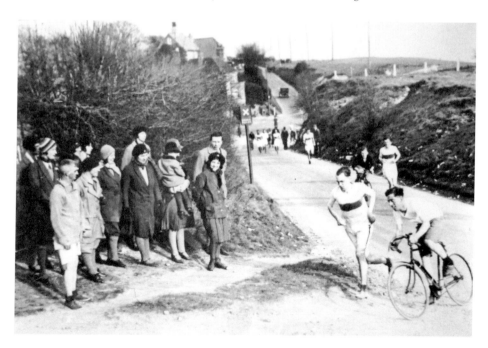

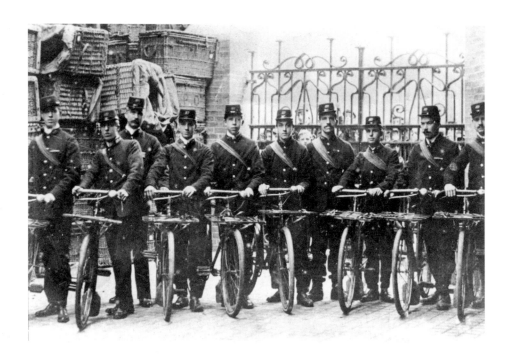

Above: Portsmouth postmen, *c.* 1908, ready to cycle off on their rounds; this being when we had two or three post deliveries a day.

Below: This sextet of beauties was on the bill at the old Hippodrome Theatre in Commercial Road, Portsmouth, *c.* 1911. Not surprisingly, their cycling act always went down well.

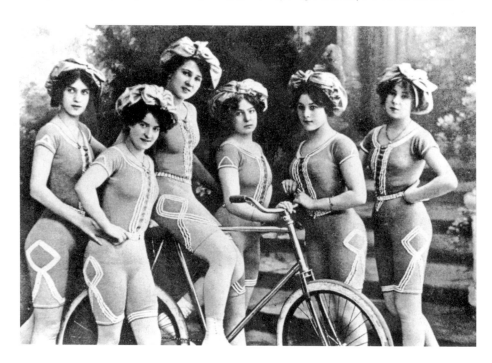

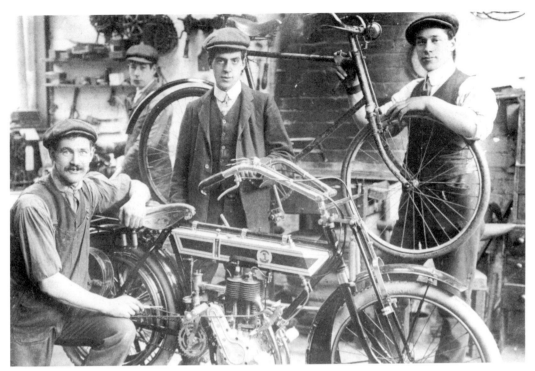

Many early bicycle dealers made the transition to motorcycles, or sold and serviced both, as did Charles Mills (extreme left in top picture) who had a shop in Clarendon Road, Southsea, *c.* 1910; his son Reg Mills is on the right. Below: a proud owner poses with his hand-change AJS bike at Fort Grange, Gosport, in 1938.

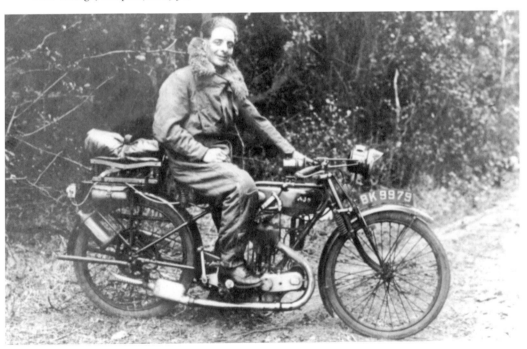

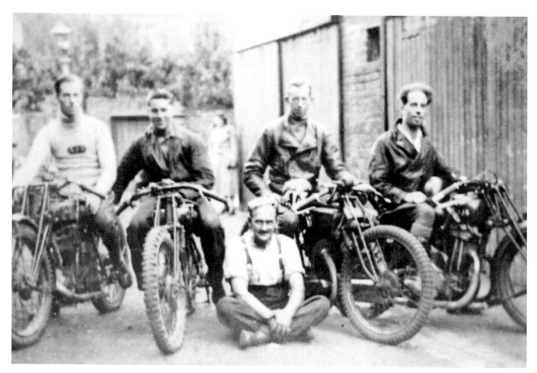

Above we feature four riders and their motorbikes at Southsea in the 1930s; seated cross-legged, centre, is dealer and mechanic Gordon Minnell. The rider second left is Ernest Hanson, who is also one of the racers pictured in the lower photograph at the Wymering track, north Portsmouth, in the 1930s.

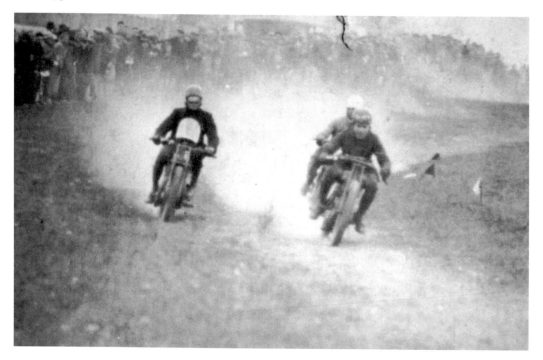

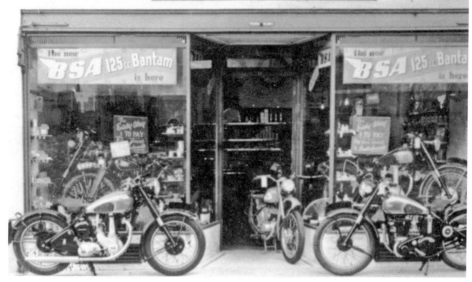

Above: Gordon Minnell's motorcycle showroom; the advert for the BSA Bantam would date the photograph as being from the 1950s.

Below: Gordon, who died in 1959, is pictured at his workshop in Clarkes Road, Landport, and the mechanic on the right is Tom Sawyers, who later took over the business.

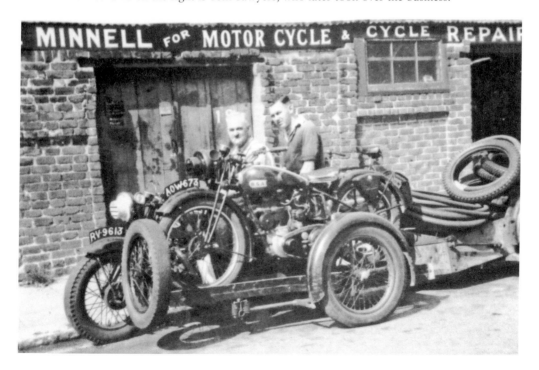

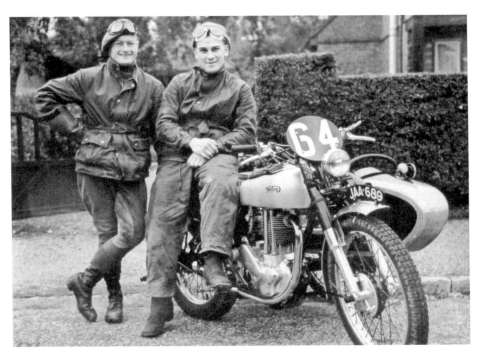

Above: Well-known Portsmouth trials motorcyclist Alan Graham Brown, sitting on the tank of his Norton bike and sidecar in the 1950s, with his sidecar passenger on the left.

Below: Riding for Norton, Alan won many trophies; he is seen here battling tough terrain in Wales at a two day trial in the 1950s.

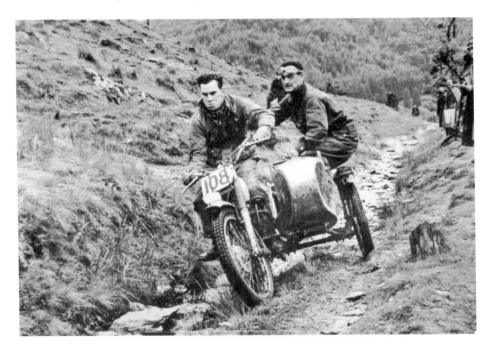

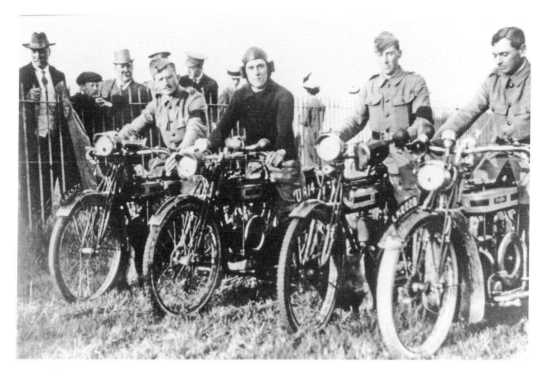

Above: Army despatch riders at Farlington during the First World War, and the four motorcycles are Douglas bikes; in fact, during that war, Douglas produced 70,000 motorcycles for the army.

Below: Portsmouth Southern Command despatch riders in the Second World War.

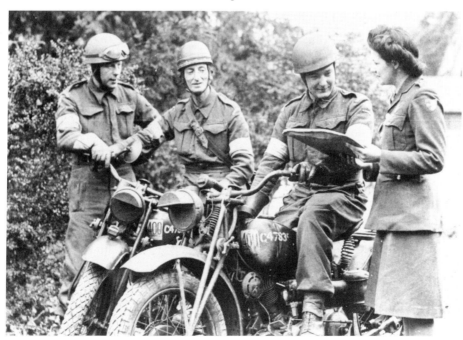

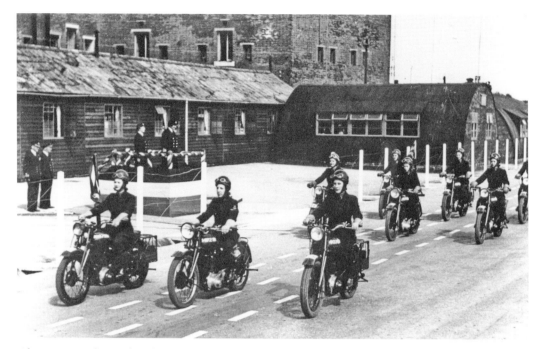

Above: Wren despatch riders at a ride-past for King George VI in 1944 at Fort Southwick, Portsdown.

Below: An OEC (Osborn Engineering Company) bike with sidecar on display at Milestones Museum, Basingstoke, in 2006. OEC originated at Gosport in the early 1900s, but later moved their works to Old Portsmouth, and later still to Stamshaw.

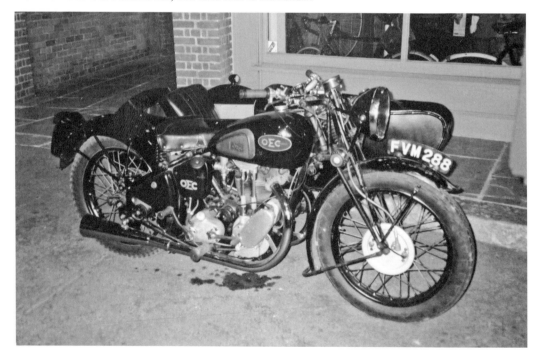

Charabanc Days

In those golden days of yesteryear, before the family car had really made its presence felt, charabanc outings were very popular, especially for works outings, when one of the essential items before setting off was to have a crate of beer in the boot. Also, it would appear strange that after arriving at seaside resorts such as Southsea, holidaymakers and visitors would embark on coach trips outside the area.

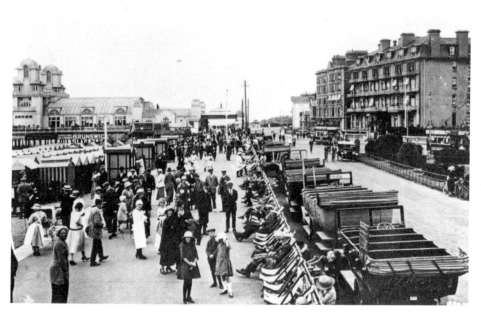

Charabancs lined up at South Parade, Southsea, in the 1920s. There was always fierce competition to attract trippers by coach company proprietors.

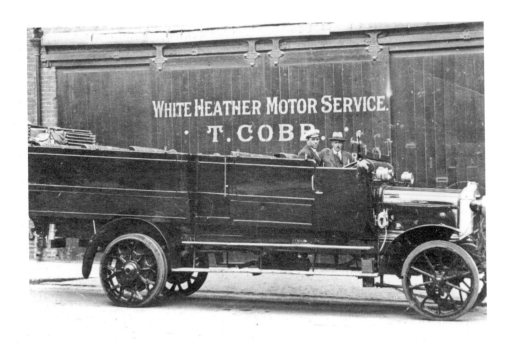

Above: In the 1920s, Portsmouth and Southsea could boast a good number of coach and charabanc operators; one of the better known was the White Heather Company which had its garage in Spring Street, Landport.

Below: The HMS *Vulcan* Band about to set off to a gig in their Daimler charabanc.

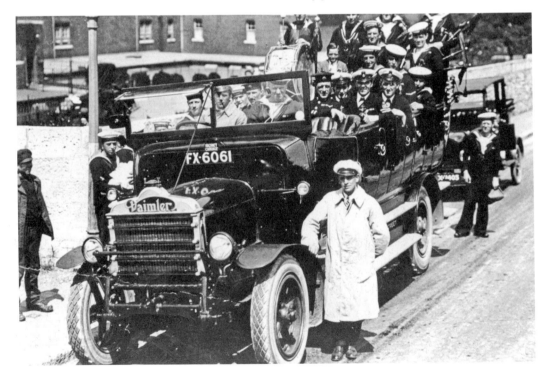

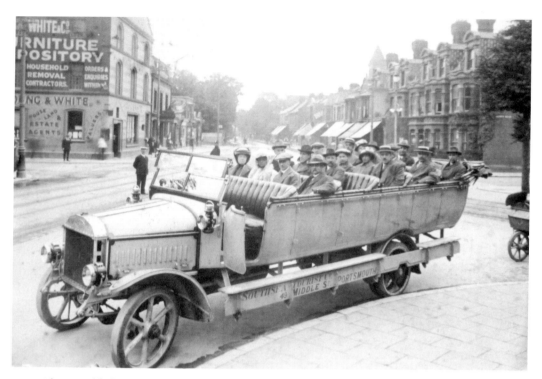

Above and below: Two photographs of Southsea Tourist Company charabancs in the 1920s. The top picture was taken in North End at the junction of London Road and Gladys Avenue, and the lower in Southsea. This coach company was owned by Frank Plater, who sold it in 1925 to the Southampton Motor Company and moved to the Isle of Wight to operate a bus and coach service there.

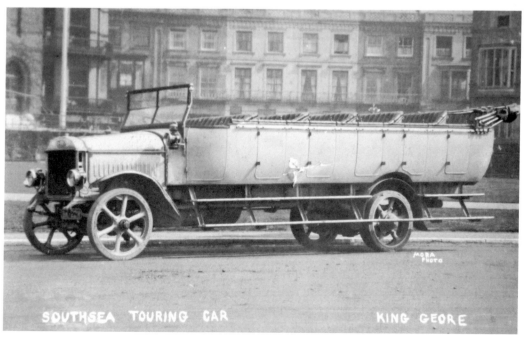

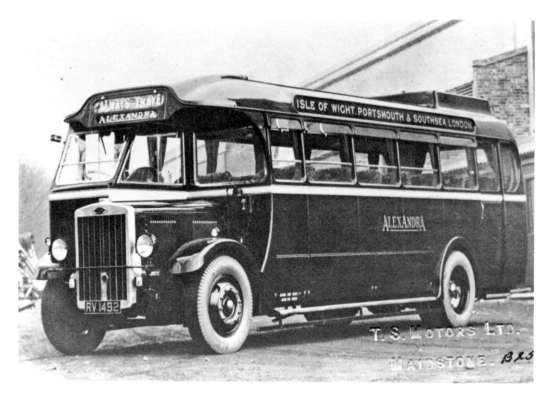

Above and below: Alexandra Coaches were founded by Percy Oliver in 1923, the same year he married his wife, who was named Alexandra. Based in Blackfriars Road, Southsea, a regular service ran between Portsmouth and London and later even went as far as Scotland. Alexandra sold out to the Southdown Company in 1935.

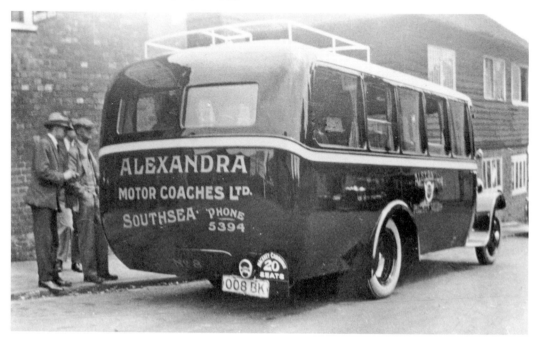

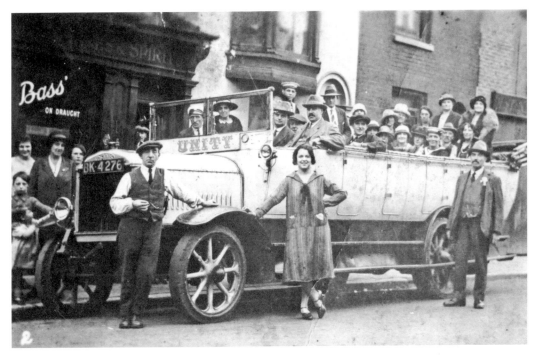

Above: A 'Portsmouth Arms' outing in 1925, taken outside the pub in King Street, Southsea. The Dennis charabanc has solid tyres.

Below: Another jolly pub outing from the 'Grantham Arms' in Somers Road, Southsea.

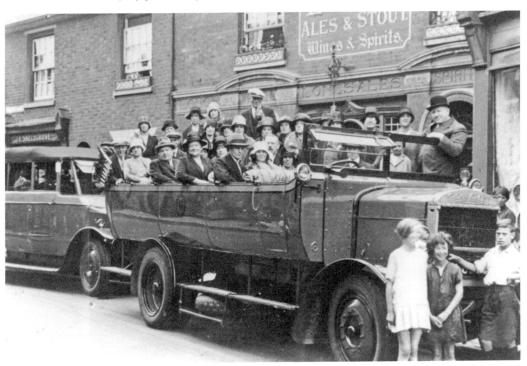

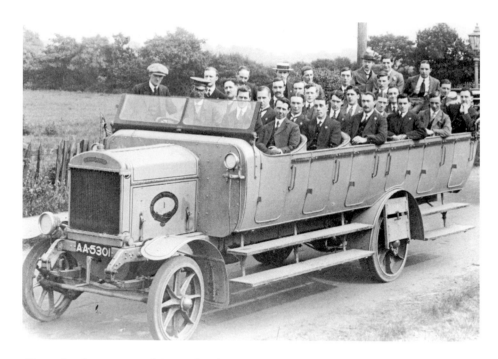

Above: In the 1920s and '30s, charabancs were very popular for works outings; here we have a Provincial coach with a full load of male trippers. Fortunately, this J-Type Thornycroft had a folding hood for inclement weather.

Below: A Portsmouth baker's outing at Hindhead in 1921, comprising at least eight charabancs.

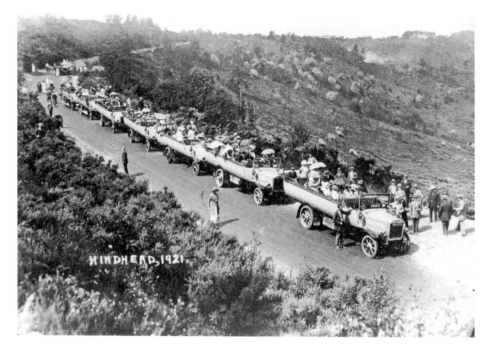

On the Buses

Transport through the ages has always been a case of 'dog eat dog' with the early days of horse coaching being swallowed by the coming of the railway, which to some extent was affected by the arrival of electric trams, which in turn were superseded by electric trolleybuses and motor buses. The motor bus stayed to dominate our roads, surviving so far despite threats to bring back the eco-friendly electric trolleybus. In fact, thanks to the introduction of free bus travel for the elderly, our local bus services have regained their former usage and popularity.

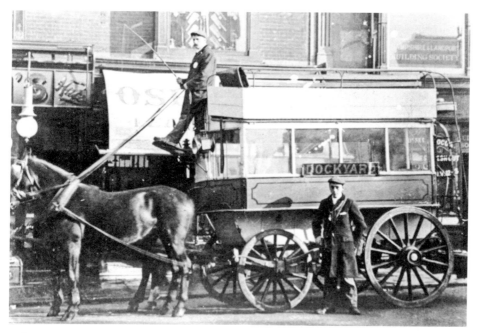

A horse-drawn bus, or omnibus, waits for passengers in Edinburgh Road, Portsmouth, before making the short journey to the dockyard, c. 1897.

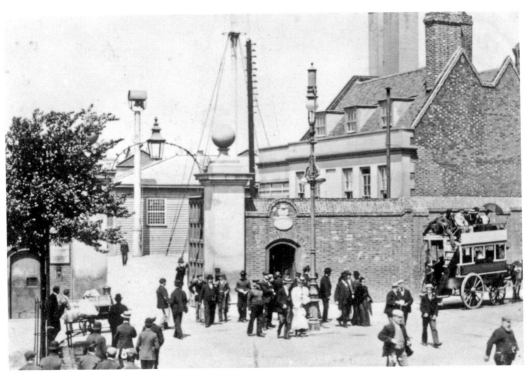

Above: A horse-drawn omnibus outside the main Dockyard Gate at The Hard, Portsmouth, *c.* 1900.

Below: A horse bus, which was known as a 'Dockyard Brake', carrying a full load from the Unicorn Gate at 'going home' time.

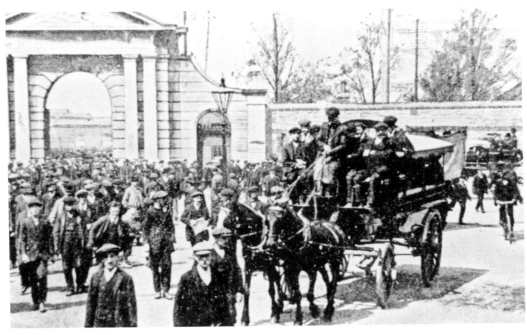

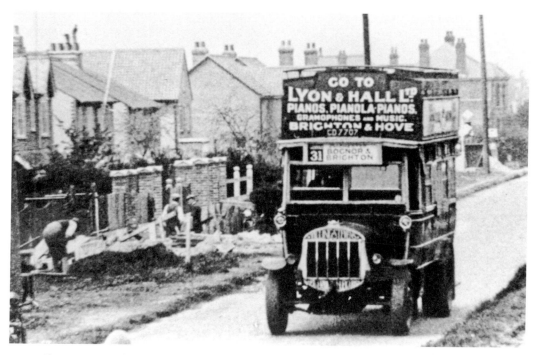

Above: Captured at Farlington, a No. 31 bus on the long haul from Portsmouth to Brighton via Bognor in the 1920s.

Below: Another 1920s view of a Southsea Tourist Company bus and crew waiting for Horndean bound passengers at South Parade Esplanade, Southsea.

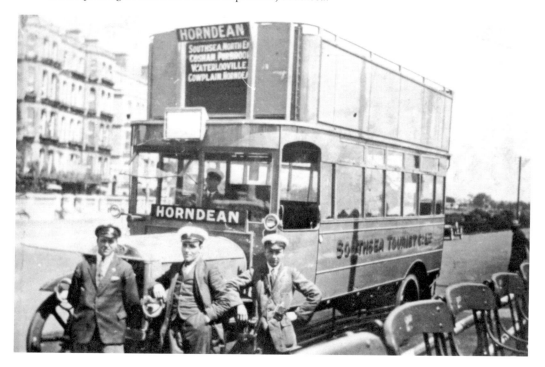

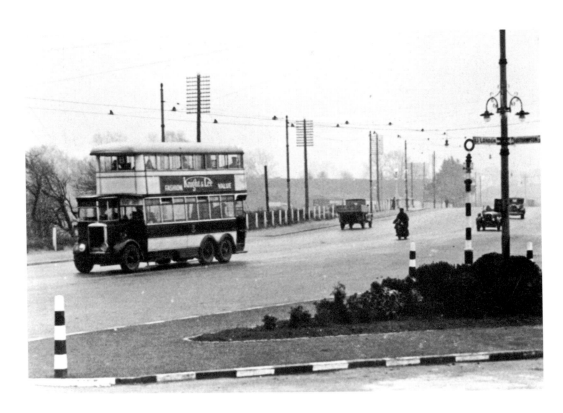

Above and below: Two photographs of Portsmouth Corporation motor buses in the late 1920s. The top picture was taken at Portsbridge, Hilsea. The first Corporation motor buses began service in Portsmouth around 1919.

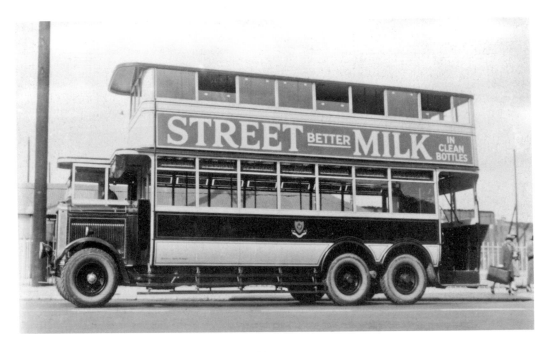

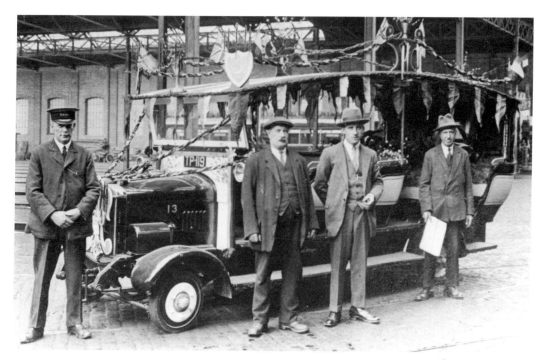

Above: Akin to the Corporation trams the motor buses were also decorated to mark special occasions. This depot photograph features one of the Guy Runabout buses introduced in 1924 and were chiefly utilised on the summer seafront service.

Below: A Southdown bus decorated to commemorate Pompey's championship season of 1948-49.

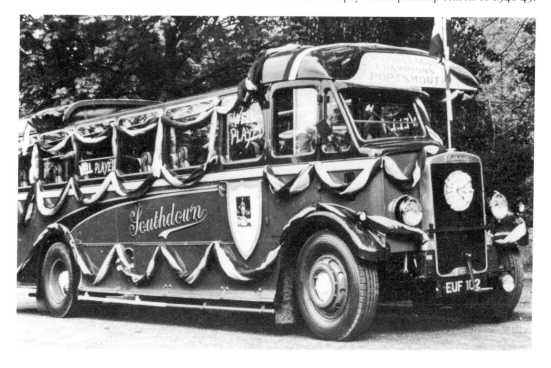

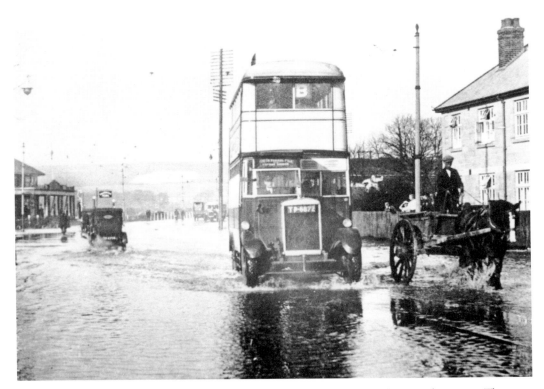

Above: A Corporation bus negotiating flood water in London Road, Hilsea, in the 1930s. The Bastion filling station can be seen extreme left.

Below: Leyland Titan bus No. 77 in Commercial Road in the post-war years.

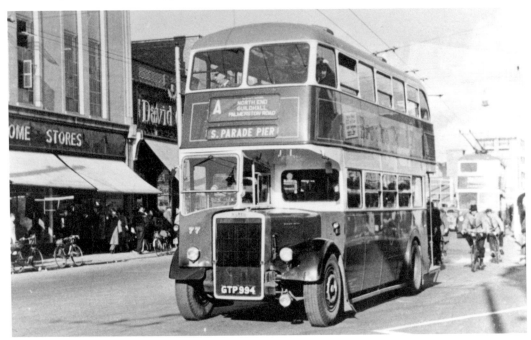

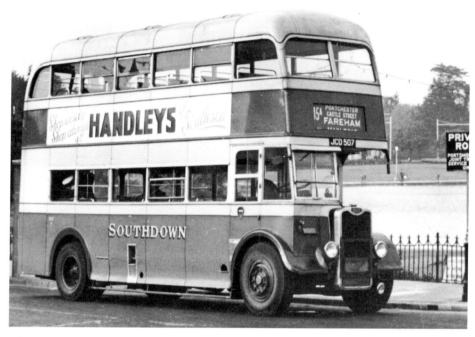

Above: A Route 15a Southdown bus alongside the Canoe Lake in Southsea. Handley's departmental store is now Debenhams.

Below: The electric Corporation trams were replaced gradually by electric trolleybuses from 1934. No. 21 is seen here at Portsbridge, Hilsea, *c.* 1936.

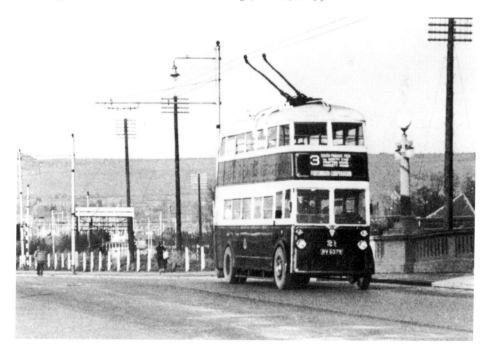

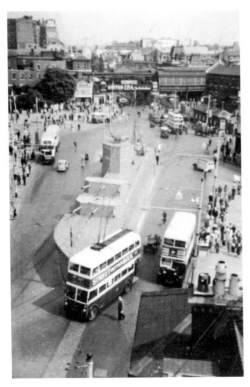

Left: Motor buses operating alongside trolleybuses in the Guildhall Square, Portsmouth, in 1937. A huge model of a warship, HMS *Coronation*, adorns the centre of the square to celebrate the crowning of King George VI.

Below: Travelling between Milton and the Dockyard is trolleybus No. 300 in the Guildhall Square, in the 1950s. Of special interest is the bus kiosk complete with clock on the left of the picture.

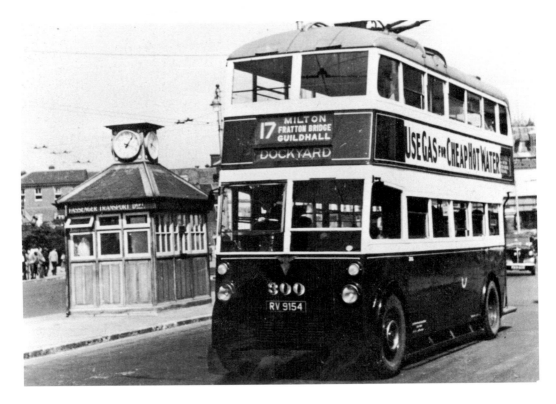

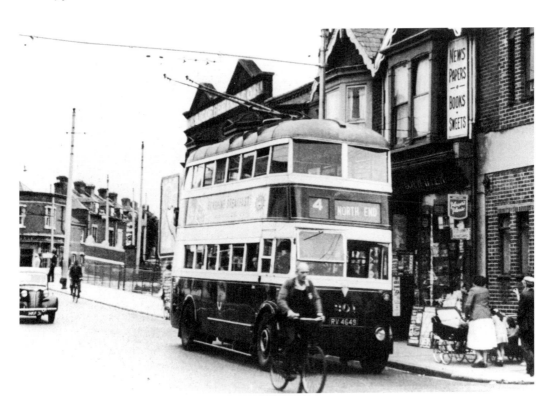

Right: A post-war view of Commercial Road, Portsmouth, looking south towards the Guildhall with an interesting mix of buses, cars and trucks of the period. On the left of this photograph a bombsite still awaits development.

Below: Having just glided over Fratton Bridge, trolleybus No. 201 is approaching the junction of Lucknow Road with Fratton Road, in the mid-1950s.

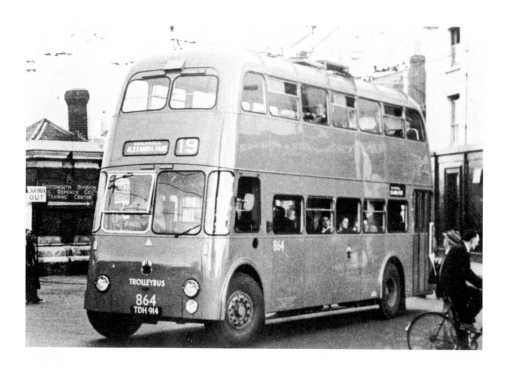

Above: Portsmouth's Guildhall Square, even as late as the 1960s, was a trolleybus spotter's paradise; here we have No. 19 *en route* to Alexandra Park.

Below: The same trolley, No. 864, at Portsmouth Hard, with driver Bill Slevin and conductor Les Ricketts.

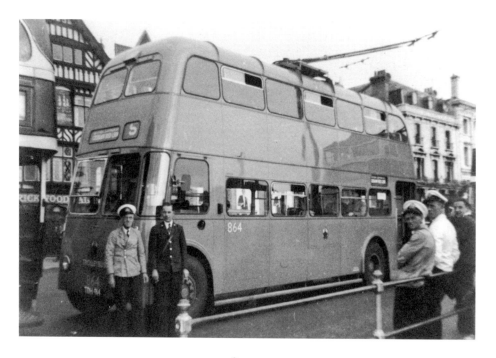

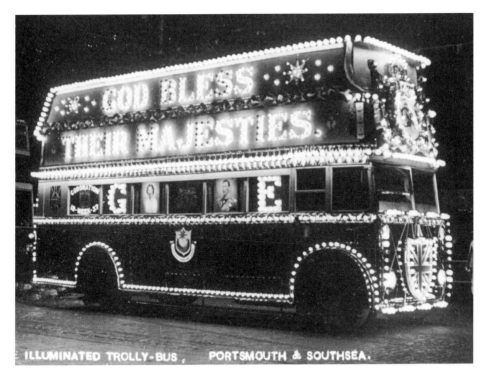

Above: Just like their forerunners, electric trams, trolleybuses were ideal as a means of marking or celebrating special occasions, as illustrated in this 1937 night time Coronation photograph.

Below: Another illuminated trolley marking the accession of Queen Elizabeth II in 1953.

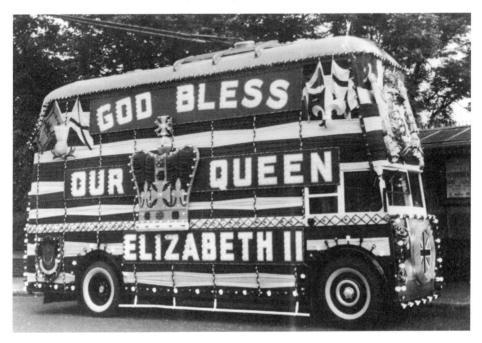

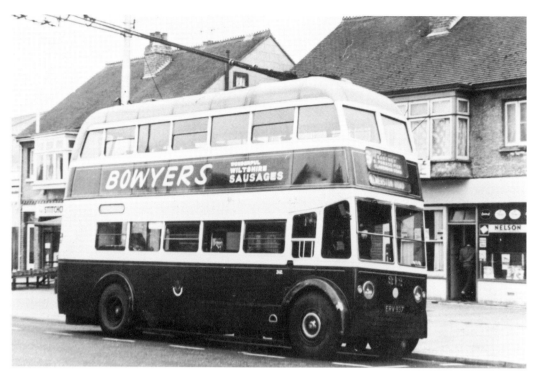

Captured prior to the demise of Portsmouth's trolleybus era, above we have a trolley in Spur Road, Cosham, and below at The Hard, Portsea. The last trolleybus in Portsmouth entered the Eastney Depot for the final time on 27 July 1963.

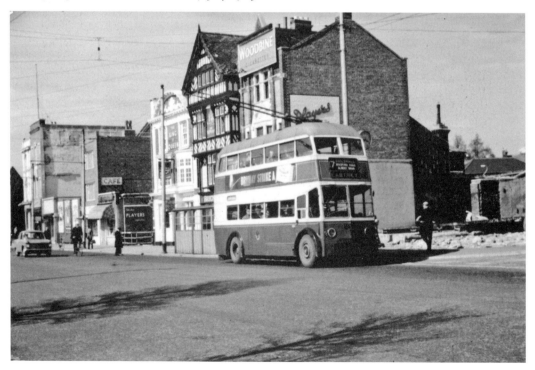

At Your Service

On initial deliberation, vehicles such as taxis, delivery vans, fire engines and steam wagons, may hardly come under the description of 'transports of delight'. However, apart from being objects of nostalgia and much sought after by collectors and enthusiasts of early transport, they also provided a vital and valued service to our local community in times long past.

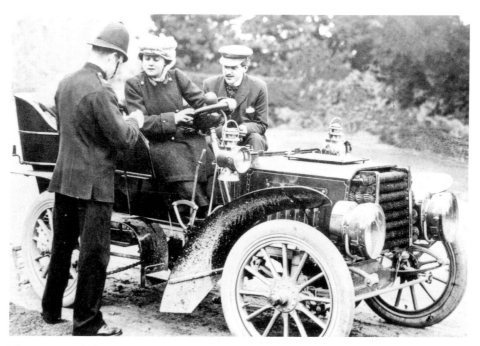

This is one of the earliest examples of a motorist being given a speeding ticket by an officer of the law. The unfortunate recipient was Portsmouth-born actress and Edwardian darling of London's West End, Evie Greene. The photograph is *c.* 1903 and the car is a British-built Napier.

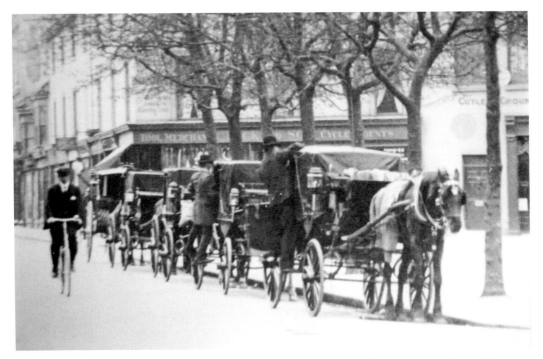

Above: Captured before motor vehicles entirely took over our streets, horse-drawn cabs waiting for hire in Portsmouth's Town Hall Square in 1906.

Below: A car hire driver and his passengers agog at the sight of Baby Jumbo of the *Daily Mirror* when the animal was on a publicity visit to Portsmouth in 1910.

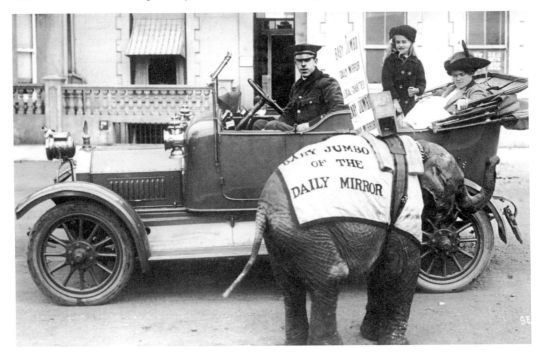

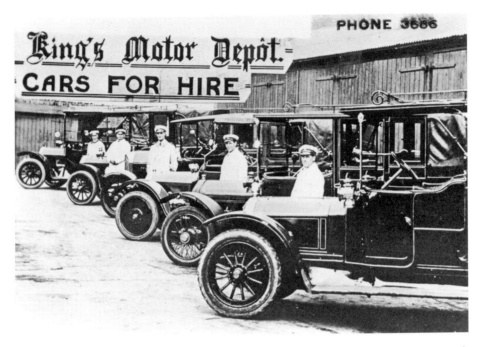

Above: A line-up of smart drivers and their hire cars at the King's Garage in Exmouth Road, Southsea, in 1906.

Below: A proud Portsmouth taxi driver poses with his gleaming cab in Henderson Road, Eastney.

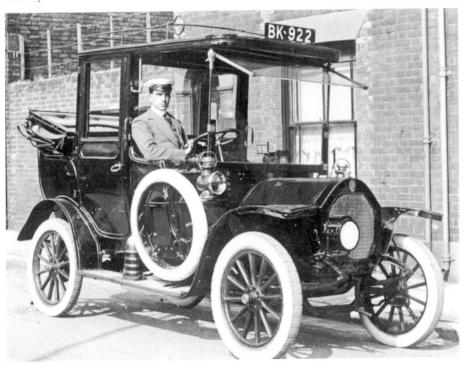

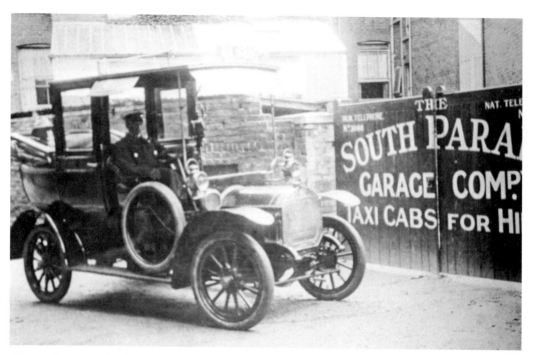

Above: Taxi cabs for hire at the South Parade Garage Company based in Clarendon Road, Southsea.

Below: Garages and lock-ups at the Granada Motor Company premises in Granada Road, Southsea, 1906.

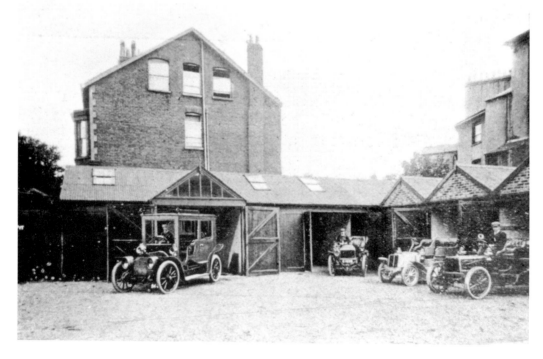

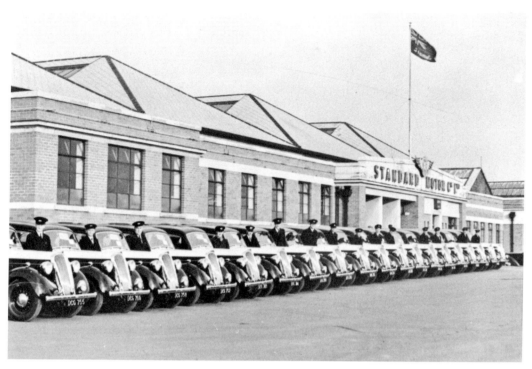

In 1939, the Streamline taxi company of Portsmouth acquired a fleet of Standard 14 vehicles. The top picture features the cars being collected from the Standard Motor Company, while below we see the new fleet on their arrival in Lion Terrace, Portsea.

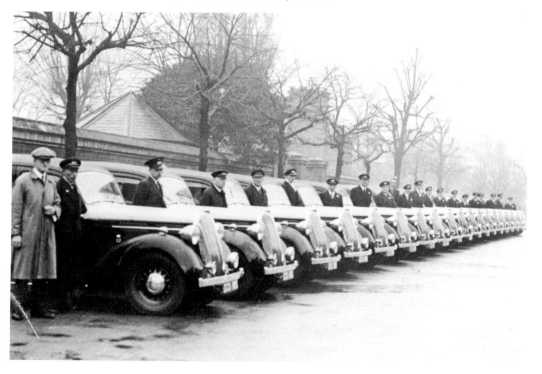

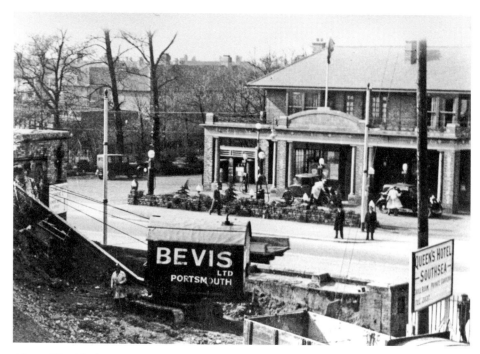

Above: The ideal spot to site a garage and petrol station is at the entrance and exit point to Portsea Island at Portsbridge; here we have the Bastion Filling Station, *c.* 1930. A Shell Station still trades from this site.

Below: Wadham Brothers had car showrooms and garages at Southsea and Waterlooville.

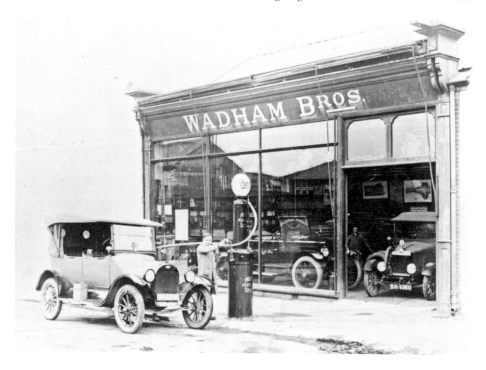

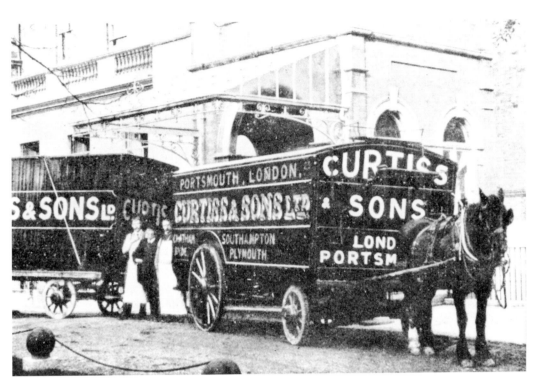

Curtiss & Sons are certainly one of the oldest and best-known carriers and removal firms in the area; in fact, they are still trading in 2010. In the top photograph we see one of their horse-drawn vans, *c.* 1906, and below a van towed by steam.

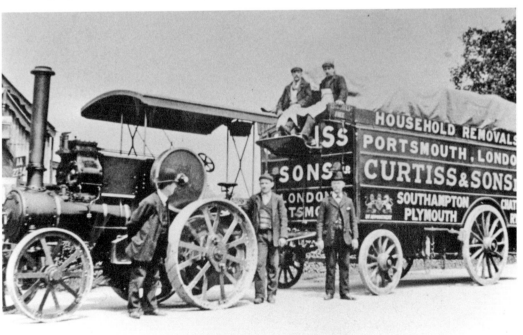

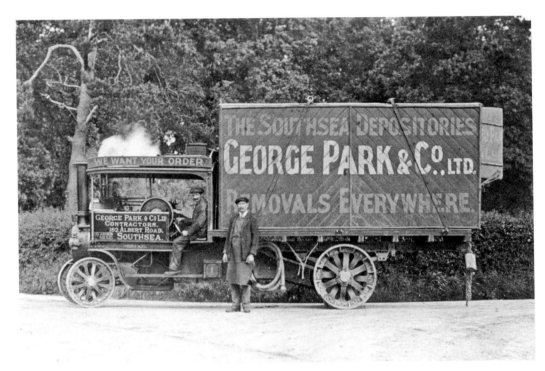

Operating from Albert Road, Southsea, carriers and removal specialists George Park & Co. were close rivals to Curtiss & Sons. The lower photograph is rather unique, as it features a Park's steam wagon transporting a huge gun across the Isle of Wight for the army in the First World War.

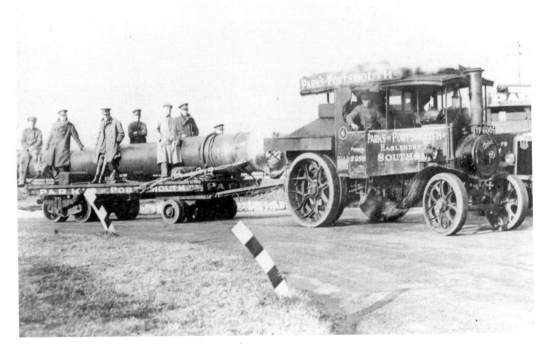

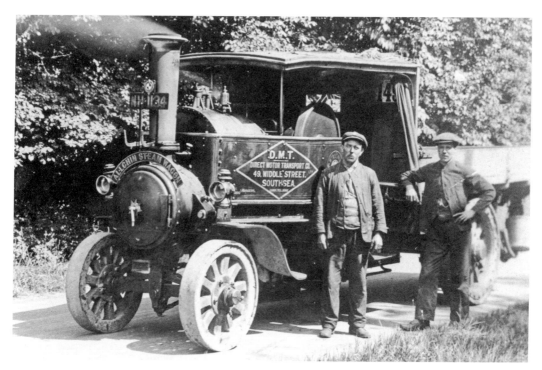

Based in Middle Street, Southsea, two drivers for DMT (Direct Motor Transport Company) pose in the top picture with their steaming Allchin steam wagon. Below, keeping our streets clean in the late 1920s, we have a Dennis road sweeping vehicle used by the City of Portsmouth Cleansing Department.

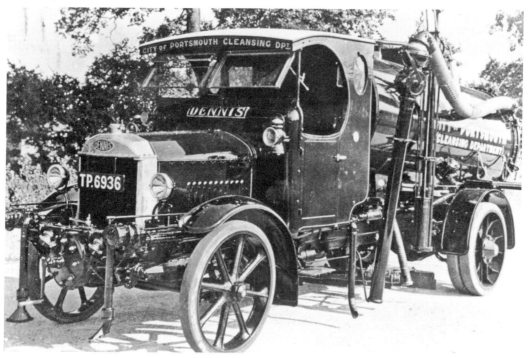

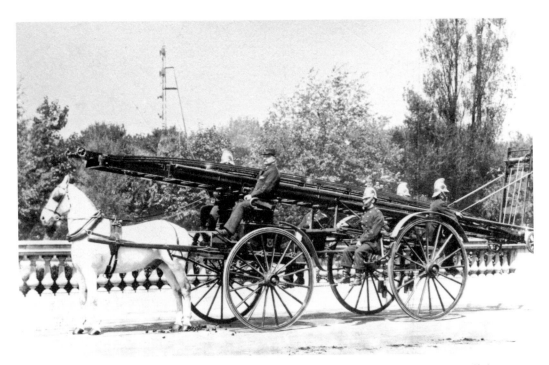

Above: The Portsmouth Fire Brigade, with Supt. John Obburn in the driving seat, show off their latest fire-fighting vehicle outside Portsmouth Town Hall, *c.* 1900.

Below: The Fire Station in nearby Park Road, which also housed the horse stables.

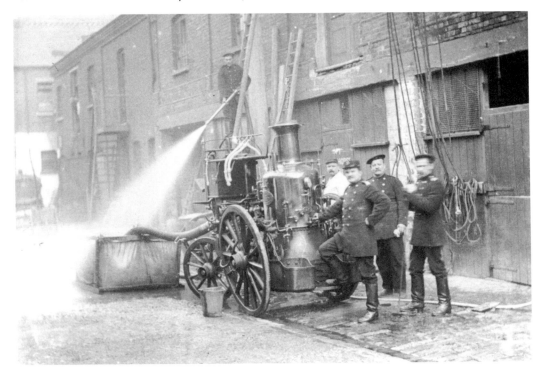

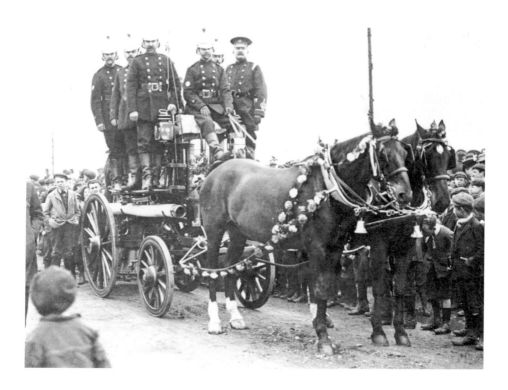

Above: The Portsmouth Fire Brigade with their horses suitably decorated at a May Day Parade in Southsea, *c.* 1906.

Below: Posing outside the Town Hall again, the PFB with a steam fire appliance, *c.* 1910.

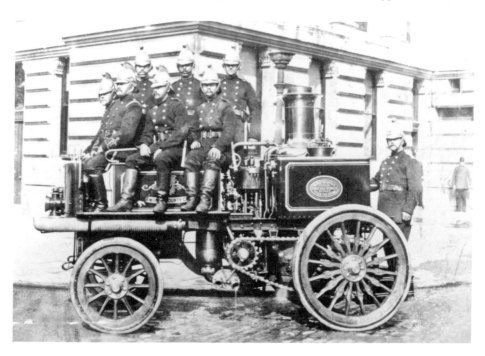

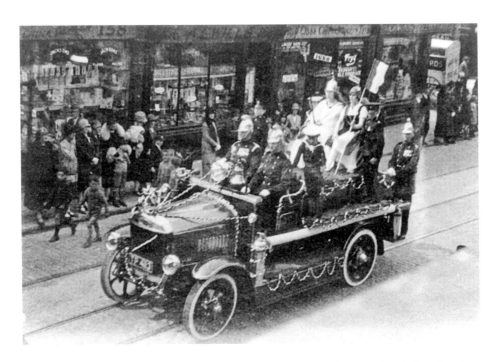

Above: A true transport of delight, a Dennis motor fire engine carrying Britannia along Fawcett Road at a local procession in 1926.

Below: Looking like a scene from a Keystone Kops silent film, the PFB drive through North End, Portsmouth, in 1935.

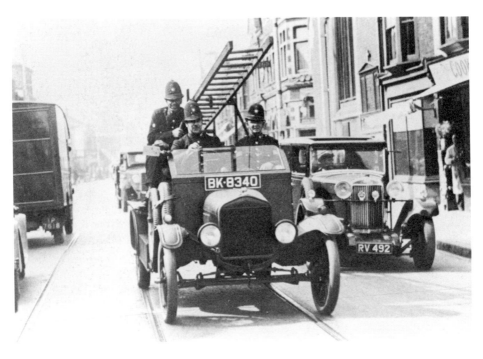

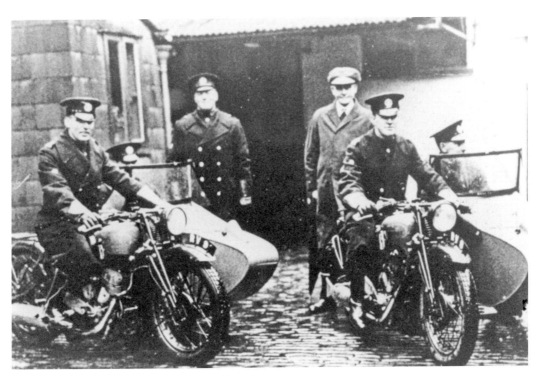

Above and *below* shows the police force in the 1920s, with their newly acquired motor cycles and car. In earlier times, the police force was joined with the fire brigade and known as the Portsmouth Borough Police Fire Brigade and manned by policemen/firemen.

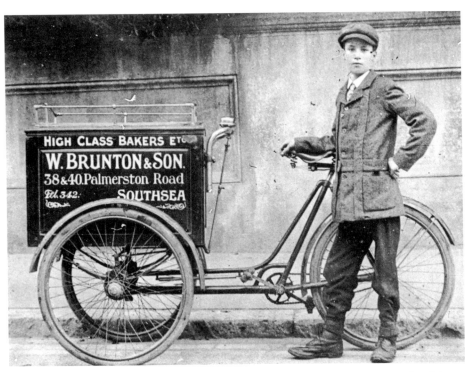

Above: A baker's boy, working for Southsea baker's Brunton & Son, poses with his delivery trike, *c.* 1910.

Below: Dairyman Arthur Gray and milk lad Ron Jupp delivering in Copnor in 1922. Before they were bought out by the larger concerns, Portsea Island had dozens of dairies.

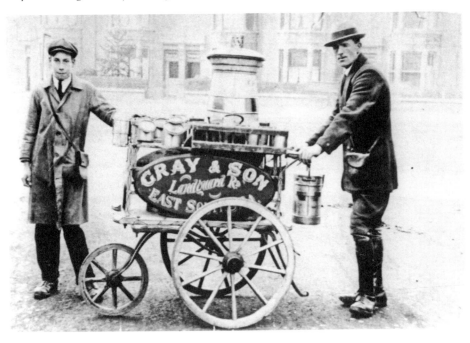

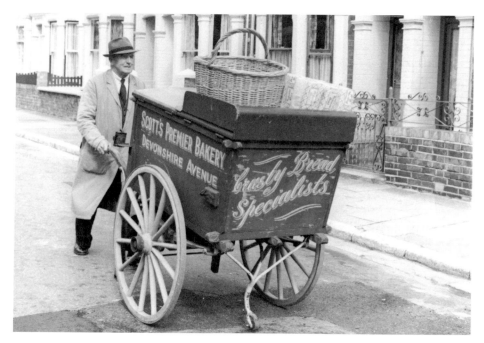

Above: A nostalgic reminder for older readers of the handcarts that brought goods to our doorsteps. This old roundsman delivered bread daily for Scott's Premier Bakery in Devonshire Avenue, Southsea.

Below: Bill Benham, known in Portsmouth as the 'Midnight Milkman', with his horse Kitty, at a local show in 1950.

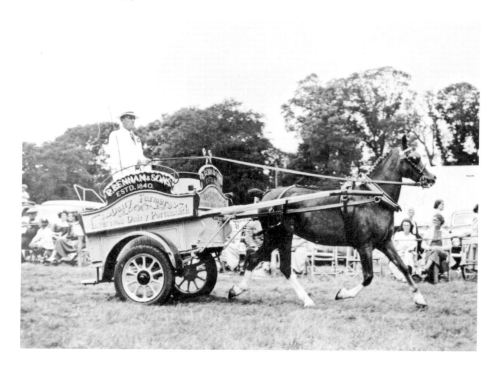

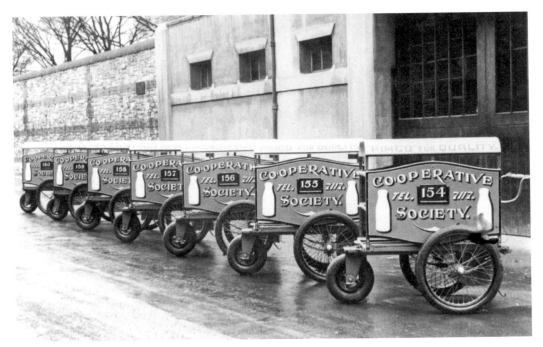

The Co-operative movement in Portsmouth was founded in 1873, gradually expanding to become the biggest provision supplier in the area. Above, we have a line-up of new milk handcarts at the Copnor Depot. The photograph below was taken to highlight old and new Co-op transport. Both photographs date from the 1930s.

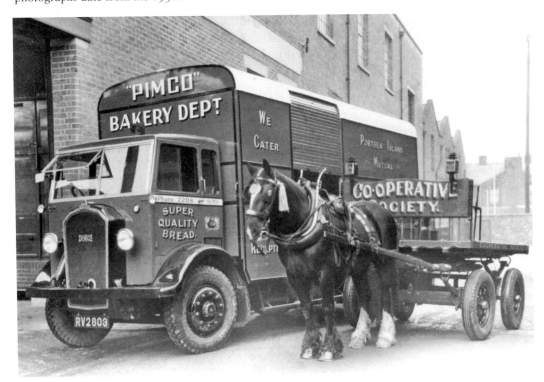

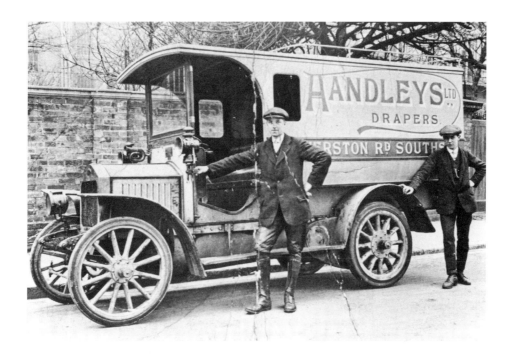

George Handley began his departmental empire in Southsea in 1869, with a small shop and one sales assistant, which expanded into a mammoth emporium employing hundreds of workers. Handley's even sold cars with a garage and servicing department, as shown in the 1920s photograph below.

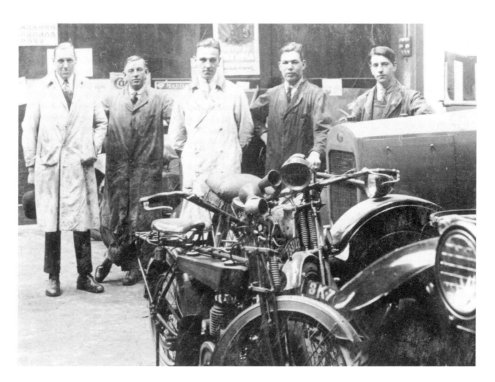

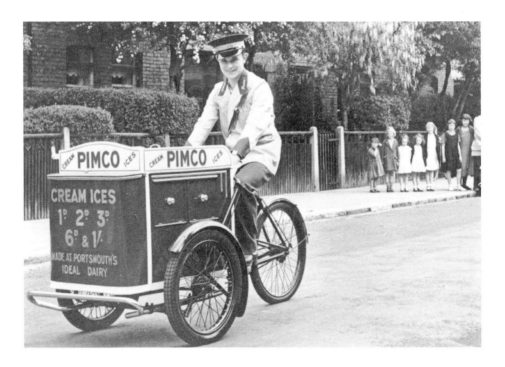

Above: In the 1930s, PIMCO (Portsea Island Mutual Co-operative Society) provided competition against the famous Wall's ice cream tricycle salesmen.

Below: Moving our transport into the 1970s, we have a Victory Brushes van; John Palmer founded this brush-making business in 1870, in Portsmouth.

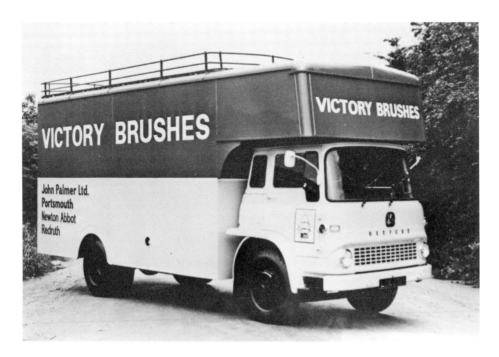

Making Tracks for Portsmouth

The first railway line into Portsmouth took place in 1847 under the auspices of the London, Brighton, and South Coast Railway. Prior to this, for travel to London by rail, inhabitants had to cross the harbour to catch a train at Gosport, where the L & SWRC had opened a station in 1841. The Portsmouth Direct Line became part of the Southern Railway in 1923 and remained such until nationalisation in 1948, the line having been electrified in 1937.

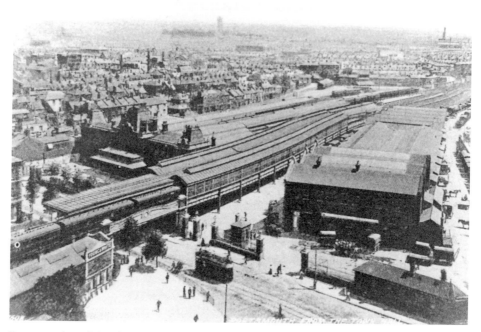

Portsmouth and Southsea Railway Station, c. 1910, captured from the top of Portsmouth Town Hall (Guildhall from 1926). Greetham Street goods yard may be seen on the right of the photograph.

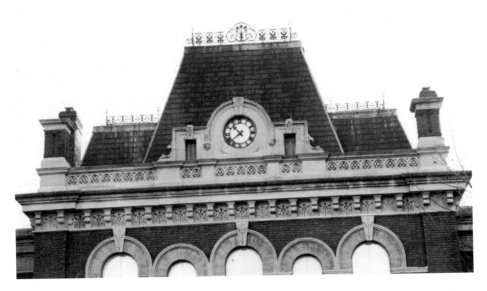

Above: The impressive façade of Portsmouth & Southsea railway station has survived and can still be admired today, despite the alterations that the building has undergone over the past century.

Below: A *c.* 1900 view taken from the station's front yard, looking across Commercial Road to the General Post Office.

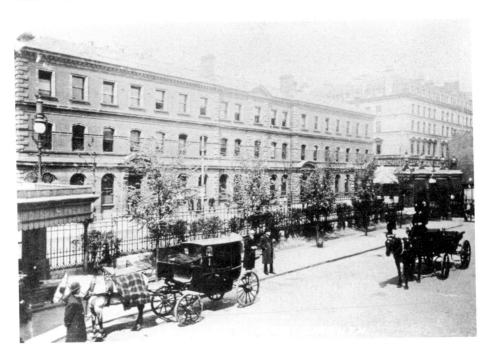

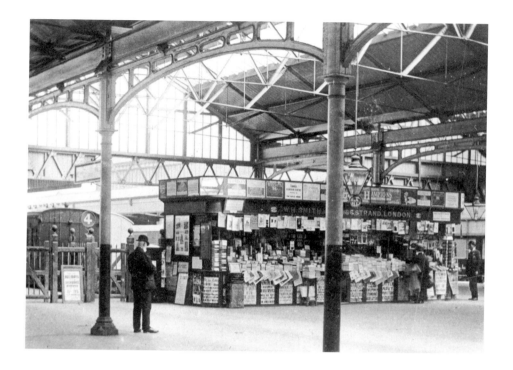

Above: An interior view of what rail travellers would have seen as they entered Portsmouth & Southsea station in the early 1900s, featuring the imposing bookstall of WH Smith & Son.

Below: A Portsmouth station staff photograph from the 1930s.

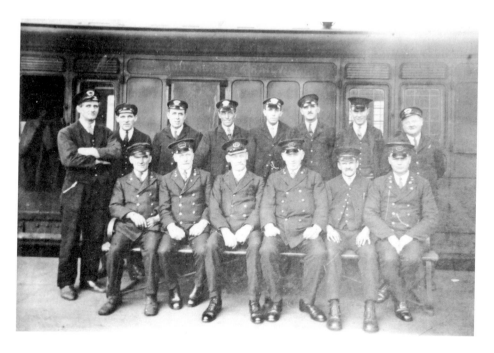

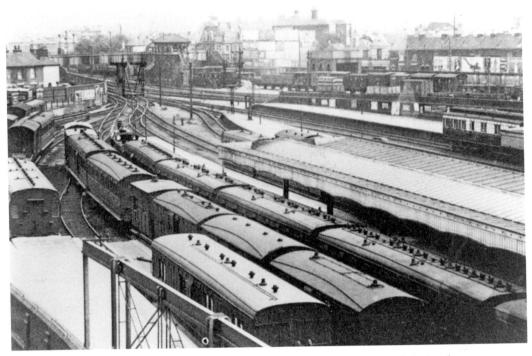

Above: A c. 1920 view of the lower level station and platforms at Portsmouth & Southsea.

Below: A Schools-class steam loco taken shortly prior to the line to Waterloo being electrified in 1937.

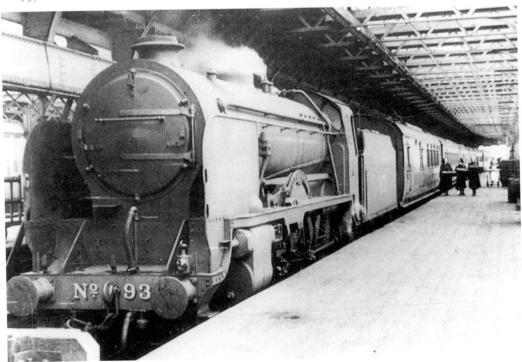

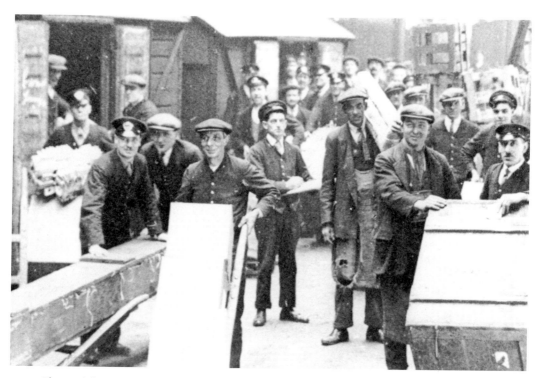

Above: A busy scene at the goods depot at Portsmouth & Southsea station in the 1930s.

Below: Loco No. 32548 approaching Portsmouth station in 1959, taken from Port Royal Place.

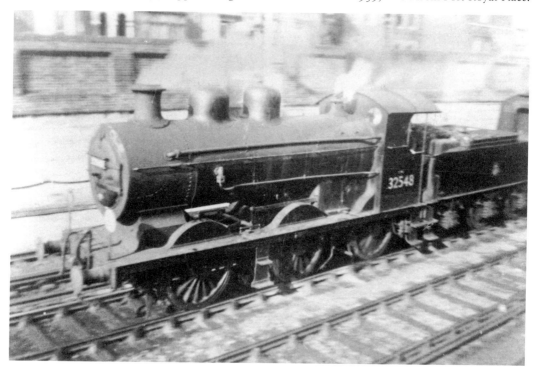

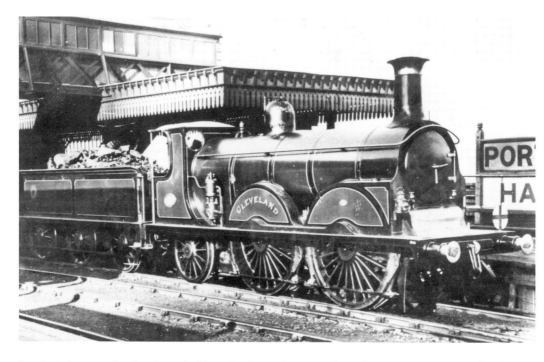

In 1876, the extension line from the Town Station to Portsmouth Harbour Station was completed, thus providing a terminal for rail passengers to embark on ferry boats for the Isle of Wight. Both photographs were taken in days of steam at Portsmouth Harbour Station.

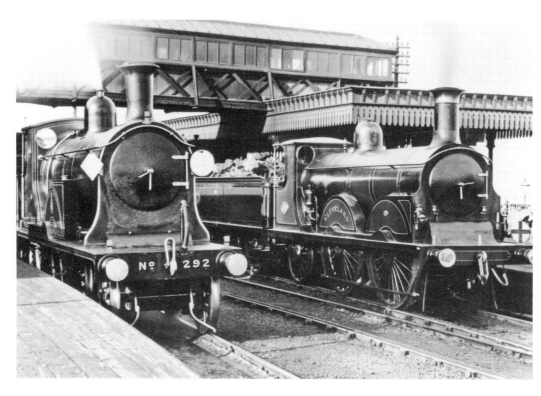

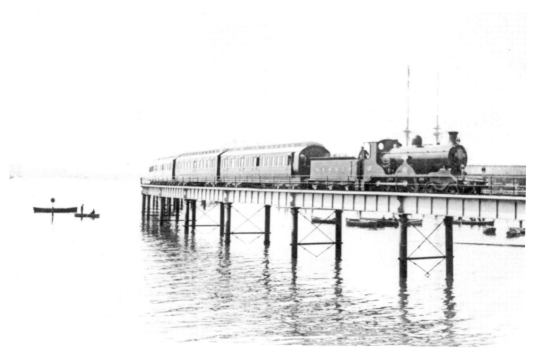

In 1878, a rail link was erected from the side of Portsmouth Harbour Station across to the South Railway Jetty in the dockyard. This extension was employed for royal arrivals and departures by boat. Above, we have the royal train leaving Portsmouth in May 1906, and below at the South Jetty in December 1910.

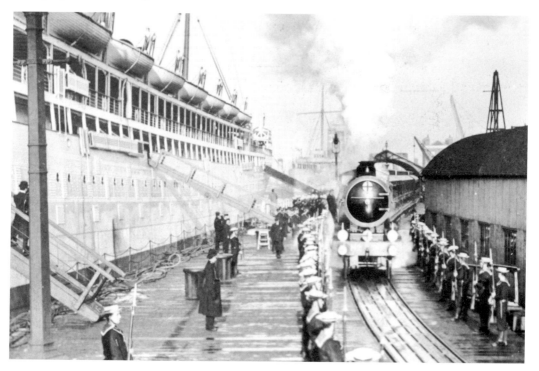

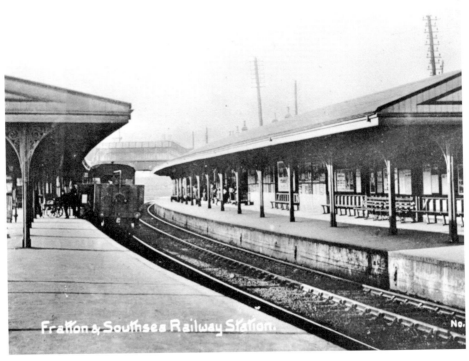

Above: In the latter half of the nineteenth century, housing development in Portsmouth increased considerably and to facilitate this, Fratton railway station was added in 1885.

Below: Fratton station staff in the 1930s.

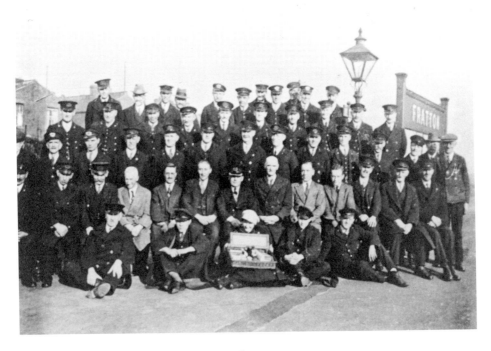

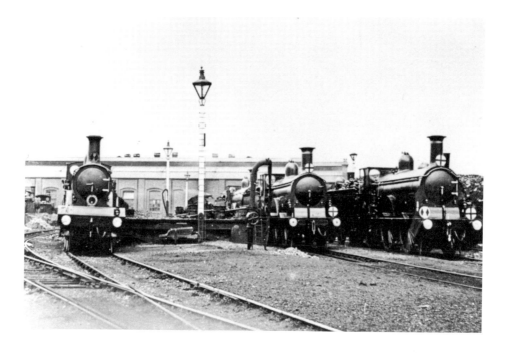

Above: Reminiscent of a scene from a *Thomas the Tank Engine* cartoon, here are three engines in Fratton Yard in the nostalgic days of steam.

Below: Another Fratton Yard photograph, but taken in the early 1950s British Railways era, the loco is a Bullied 'West Country'.

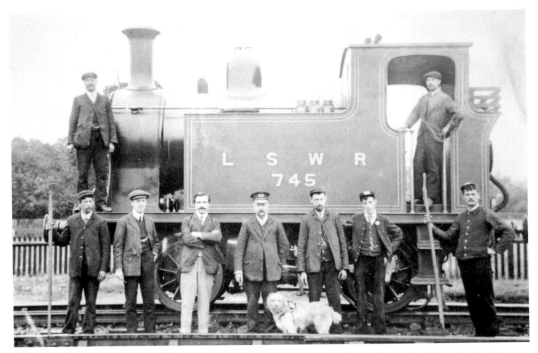

Above: Pictured at Cosham railway siding in pre-Southern Railway days, London & South Western Railway loco 745 with nine men and a dog.

Below: Photographs of signal box interiors are fairly rare; this was captured at the Fratton East box.

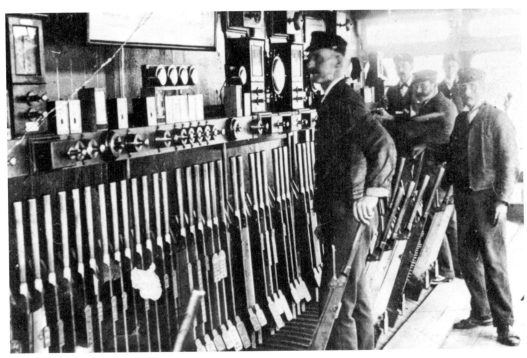

From 1885, Fratton station had a branch platform to serve the East Southsea Railway which terminated at a station in Granada Road, the site of which is pictured above, while below we have a rail-car which was introduced in 1903. Sadly, this railway service was not a great success and ceased running in 1914.

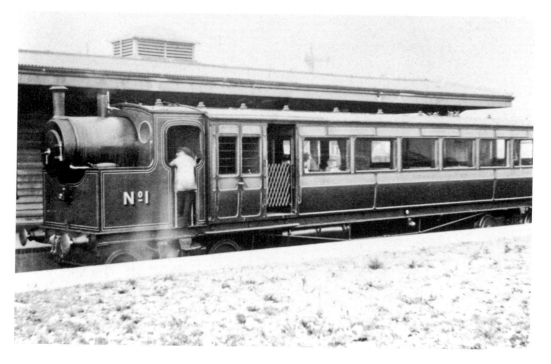

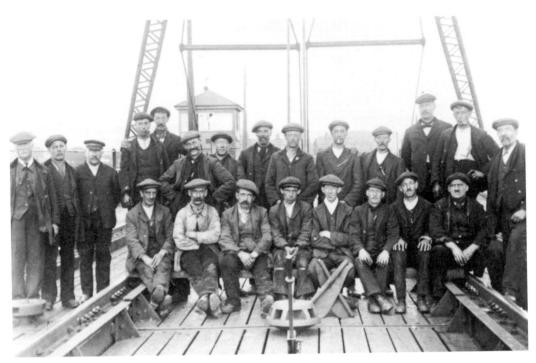

Above: A gang of railway workers on Portscreek rail bridge, *c.* 1910.

Below: Taken around the same period, this is the railway crossing at Cosham with the footbridge on the extreme right and the Railway Hotel centre.

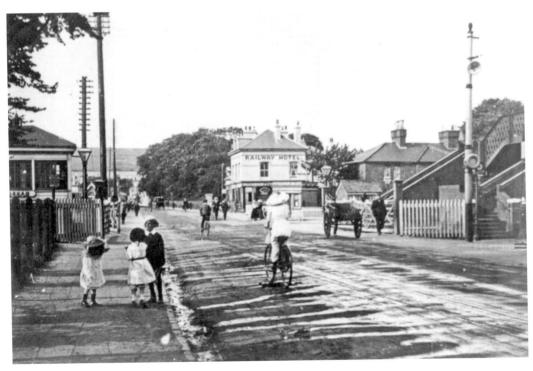

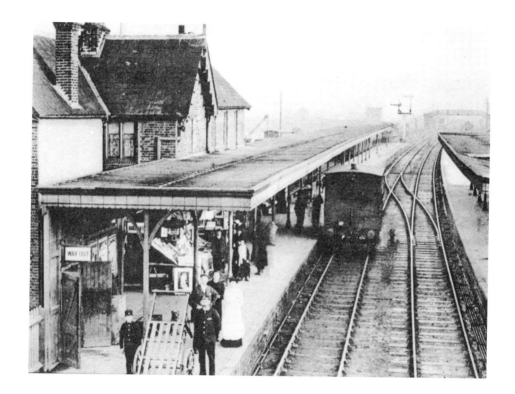

Above: Cosham Railway Station, *c.* 1908. This station opened in 1848 when the line west to Fareham was completed under the L & SWR, and still survives as a busy rail link.

Below: 'A' Company of the Royal Hampshire Regiment TA, *en route* for summer camp at Cosham station in 1952.

Above: The Southern Railway electrified the main line from London to Portsmouth in 1937; here we have the first electric train leaving Waterloo, bound for Portsmouth on 4 July that year.

Below: Holidaymakers leaving Portsmouth by rail at the declaration of war in September 1939.

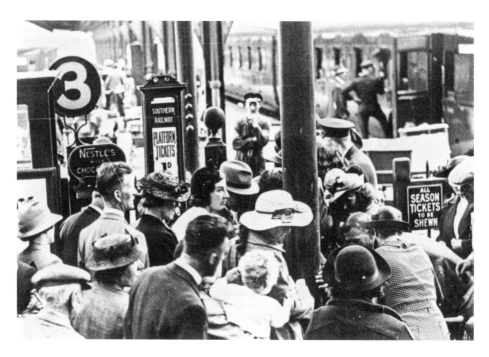

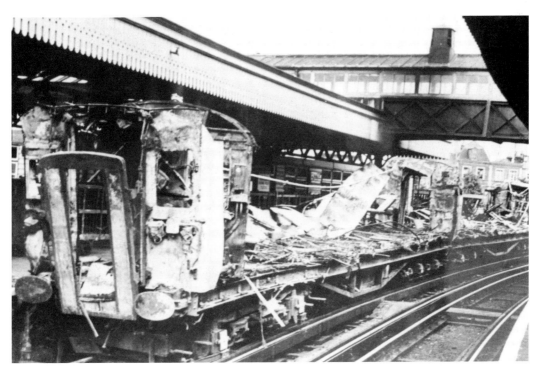

During the Second World War, in the August of 1940, Portsmouth Harbour Station was the first local station to suffer from heavy bombing, as highlighted in this photograph of train wreckage taken the next day. Below, we see local coal carts and lorries at Fratton station during a coal shortage in 1940.

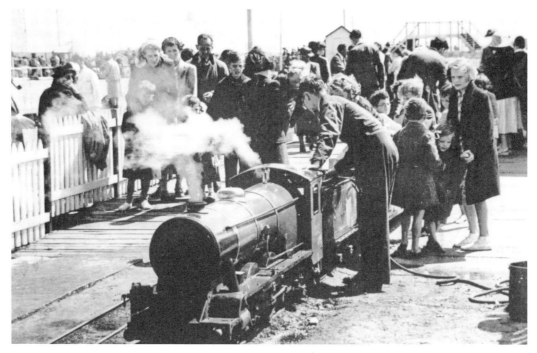

Opened in 1924 by the Portsmouth Corporation, the Southsea Miniature Railway proved a great seaside attraction before closing in the 1980s. The top photograph was taken in the 1953 August Bank Holiday, while the lower features the railway turntable in action. Hilsea Lido also had a miniature railway.

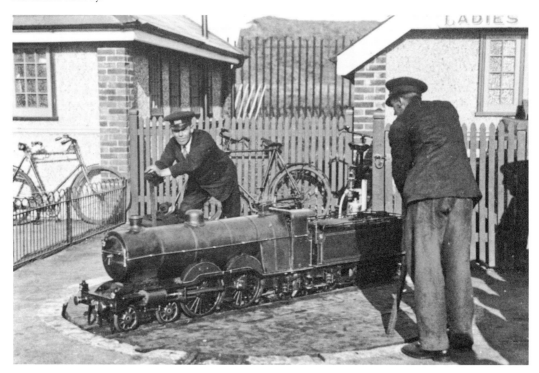

Wings over Portsmouth

The advancement of air travel for business and pleasure over the past fifty years or so has been considerable. For a city with the population and size of Portsmouth not to have an airport could today be deemed inconceivable, but its residents have to travel to Southampton, Bournemouth or Gatwick to fly to foreign parts. However, this was not always so, for Portsmouth once boasted its own municipal airport; in fact, it had this facility for over forty years, and in the following pages we are pleased to provide a brief pictorial reminder of its colourful past.

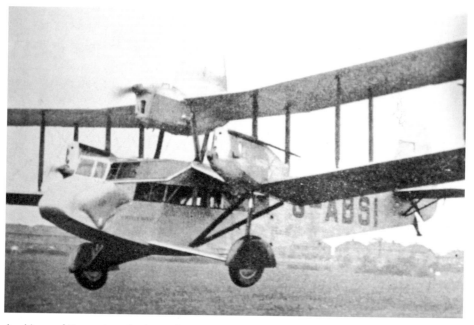

An Airspeed Ferry aircraft pictured at Portsmouth aerodrome in the 1930s. This decade was no doubt the happiest in the airport's history.

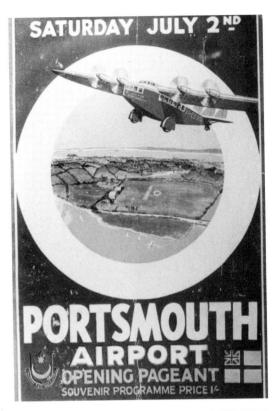

Left: Opening programme for Portsmouth Airport on 2 July 1932. A few years prior to this the Corporation purchased and acquired some 260 acres of land, including the former Highgrove Farm, north-east of Portsea Island, for the venture.

Below: An early aerial view of the airport. One of the first landings took place in June 1931, a year before the official opening; the pilot was Charles Scott and his passenger was renowned journalist Hannan Swaffer.

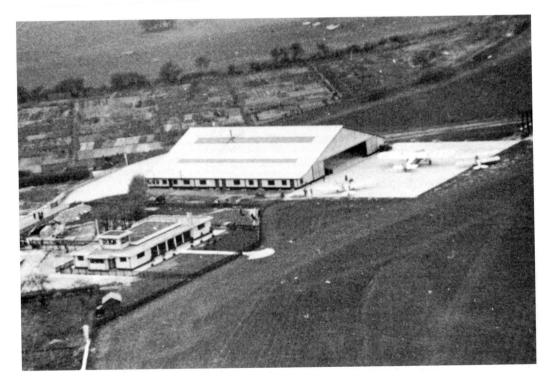

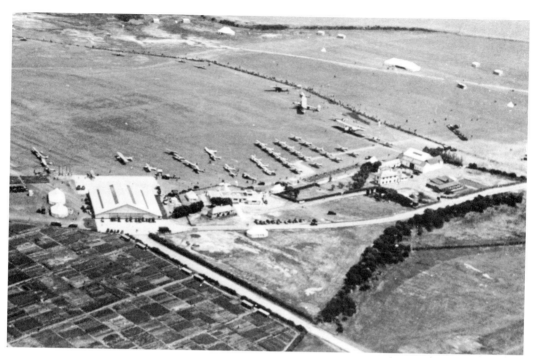

Above: Another 1930s view of the airport looking north, with over forty aircraft on the field.

Below: Portsmouth Lord Mayor Alderman F. G. Foster and his Mayoress board Imperial Airways liner *City of Liverpool* for a flight over the city on the airport opening day.

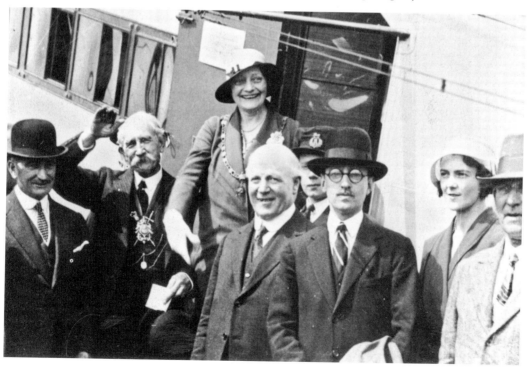

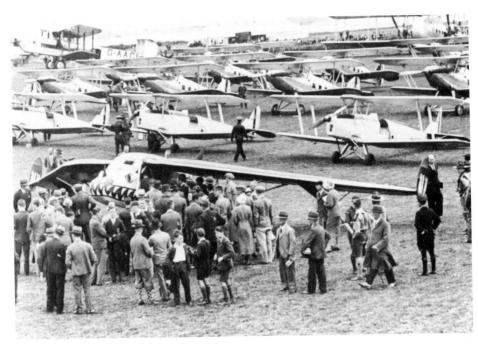

Above: Another airport opening day photograph showing the varied assortment of aircraft on display. Over 50,000 people attended the event and, as the picture confirms, there was a lot of interest in the prehistoric-styled Westland-Hill 'Pterodactyl' plane.

Below: Airspeed Ferry G-ABSI which came into service in 1932.

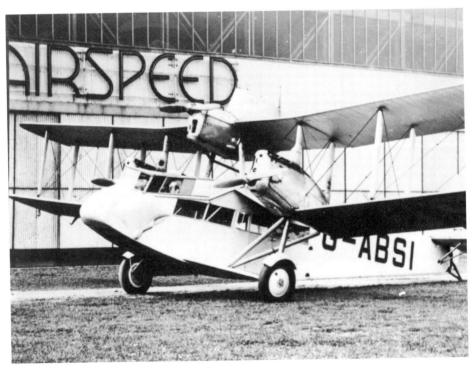

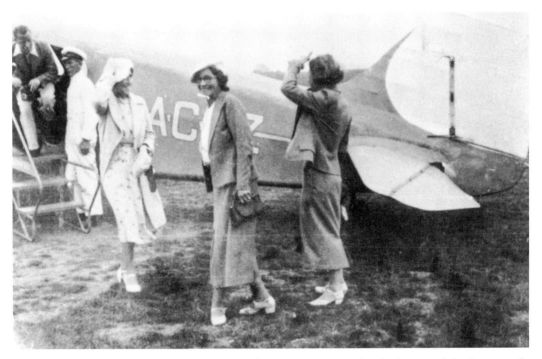

In 1932, the first air passenger service at the airport began under the banner of the Portsmouth, Southsea, & IOW Aviation and flights to and from the island cost the tripper 6s 8d (33p) return. These were very popular during bank holiday periods.

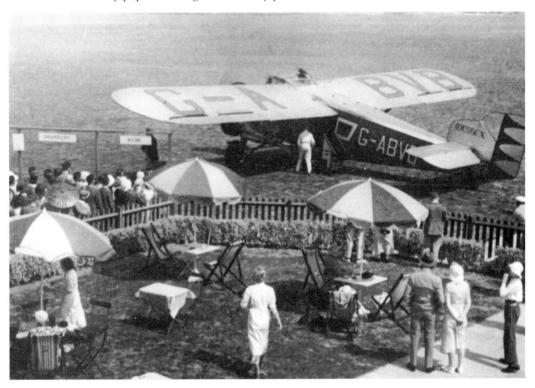

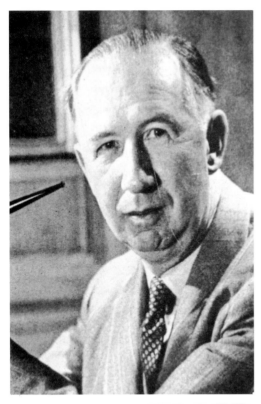

Left: Novelist and aviation pioneer Nevil Shute, who came to Portsmouth in 1933 with Airspeed, a company that started up in an old bus depot in York before moving their works south to Hampshire. Airspeed employed nearly 200 men in aircraft production. Shute (1899-1960) was a brilliant designer and remained in Portsmouth until 1938, before leaving to find fame as an author.

Below: Workers on the factory floor in the 1930s, assembling an Airspeed Courier plane. Through the war they produced Oxford's and Horsa troop gliders. Airspeed was later taken over by De Havilland and later still by Hawker Siddeley.

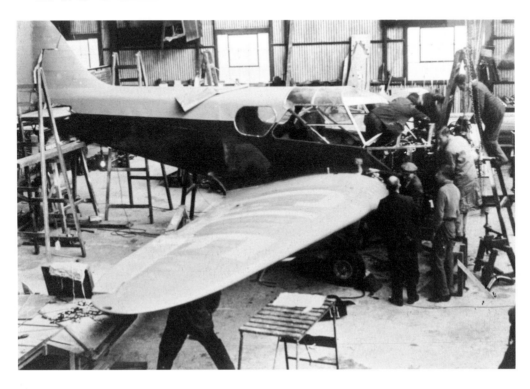

Right: Famous female aviator Amy Johnson, who was no stranger to Portsmouth, for she flew for the PS & IOW Aviation Company and lived in a flat at Cosham at one time. After her divorce to fellow aviator Jim Mollison in 1938, in 1939 she joined the Air Transport Auxiliary. In 1941, her plane disappeared over the Thames Estuary and Amy was presumed dead.

Below: Airspeed Courier GACLF at Portsmouth airport in the 1930s.

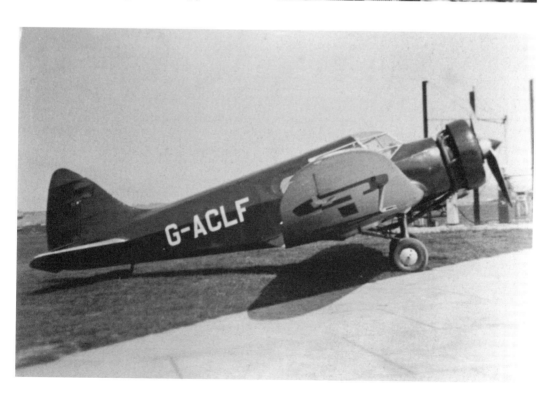

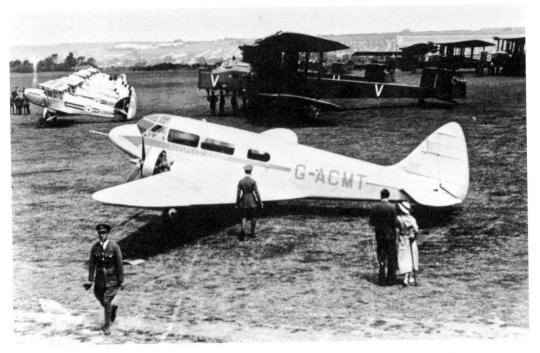

Above: Airspeed Envoy G-ACMT in the foreground of a line-up aircraft at Portsmouth.

Below: Puss Moth G-AAXY. In 1936, Portsmouth airport attracted publicity when two local Communists stole a plane and attempted to fly it to Spain, but crashed on take off, killing one of the men.

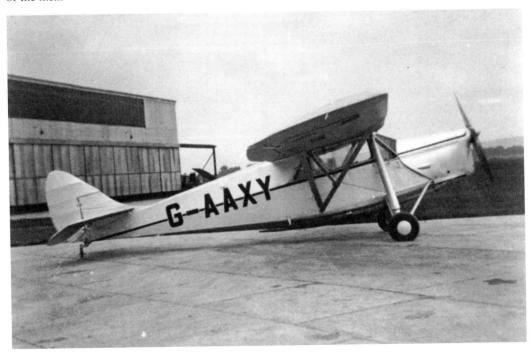

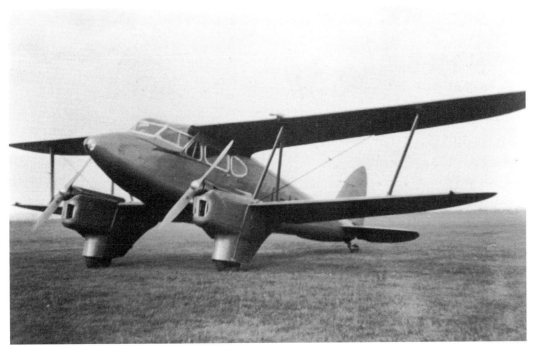

Above: A De Havilland Dragon Fly at Portsmouth.

Below: What a way to start a marriage! A Portsmouth couple is surrounded by family and friends at the airport, before flying off to Jersey for their honeymoon.

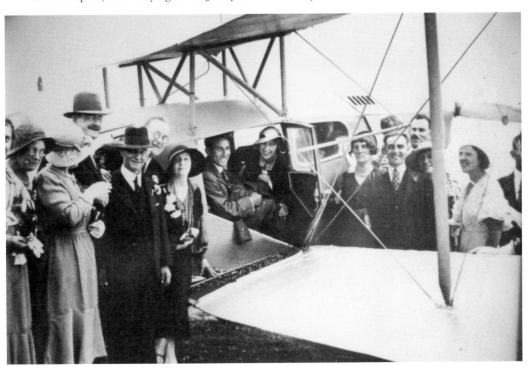

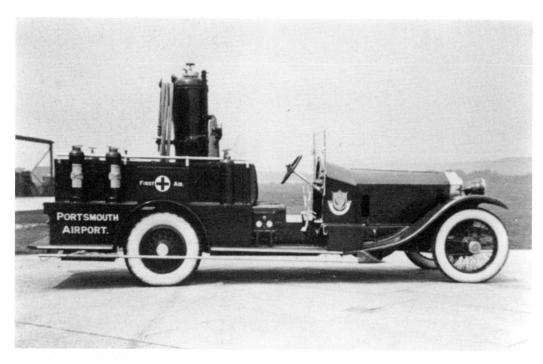

Above: Portsmouth Airport fire tender, 1930s.

Below: A Channel Airways 748 crashes to block the Eastern Road in 1967. Incidents such as this helped to bring about the closure of the airport in 1973, when a JF Airlines Islander plane was the last aircraft to land and take off from the airport.

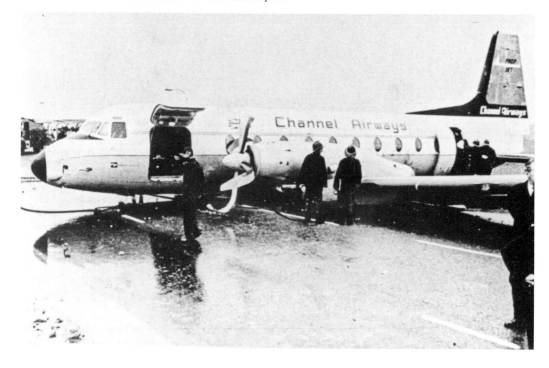

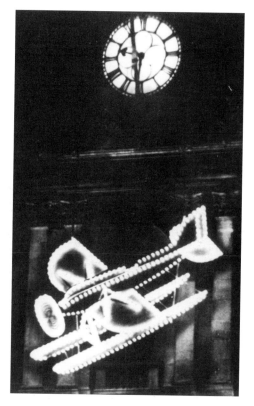

Right: Portsmouth Guildhall clock illuminated for the 1931 Schneider Trophy seaplane races that took place over the Solent. This event was held in 1929 and 1931 and attracted many of spectators to the area.

Below: Flt Lt Stainforth (inset) and the Supermarine seaplane that he won the trophy with in 1931, thus Britain winning the cup outright. Flying Officer Waghorn had won the race earlier in 1929. The Supermarine S.6.B. was the brainchild of designer R. G. Mitchell who went on to design the Spitfire.

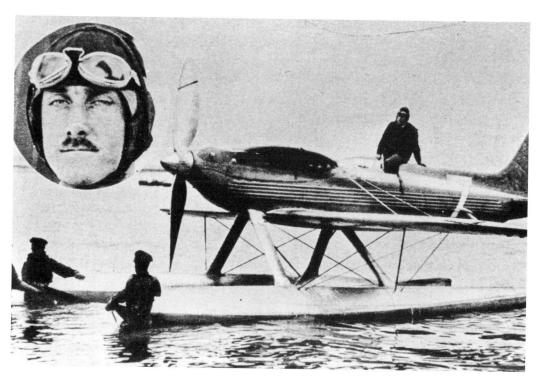

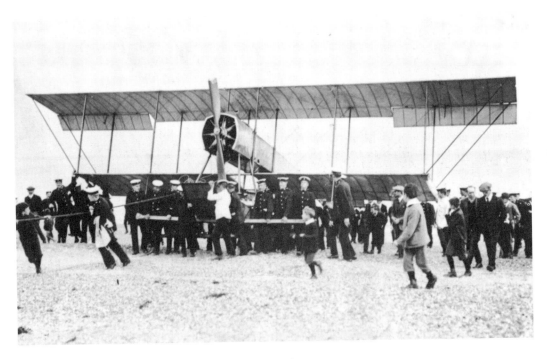

Above: Naval Hydroplane No. 5 at Eastney beach, July 1912.

Below: A glider being launched from Portsdown Hill in 1930, after being hooked to a long bungee pulled back by Portsmouth Gliding Club members. The pilot was a German named Kronfield.

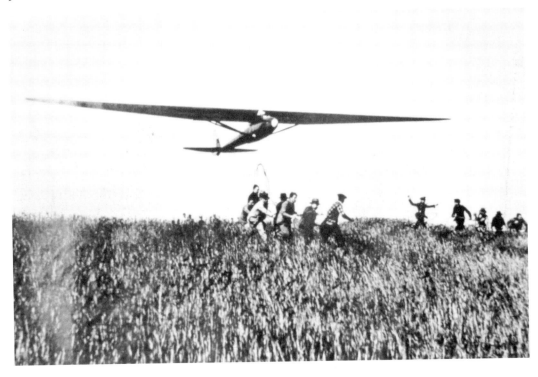

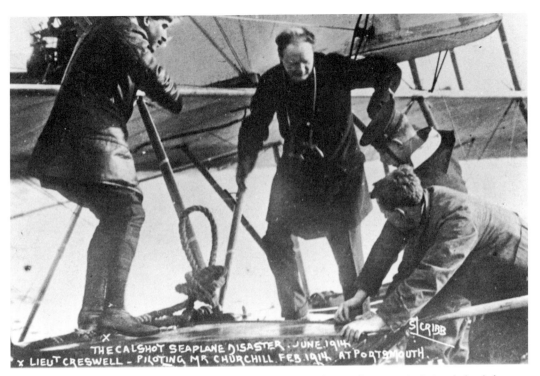

Winston Churchill, who was 1st Lord of the Admiralty at the time, is being helped from a seaplane in Portsmouth Harbour, in February 1914. In the lower photograph, Churchill is seen arriving by plane at Hilsea Drill Field, Portsmouth, in May 1914.

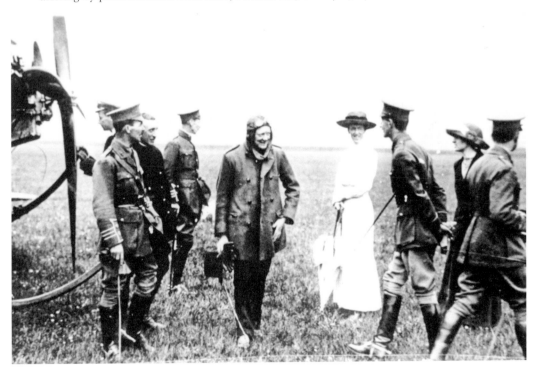

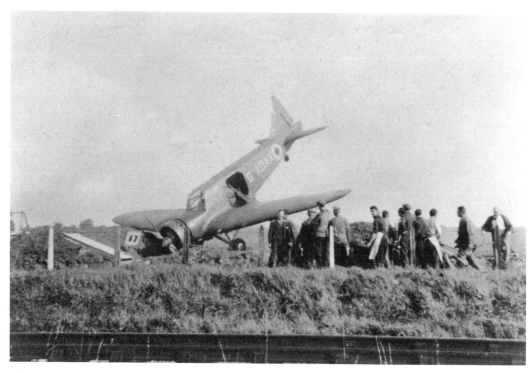

Above: Oooops! Airspeed Courier G-ADAX makes a crash landing at Yeovil Airport in 1939.

Below: A Spitfire fighter plane on display by the steps of Portsmouth Guildhall. In the Second World War, the people of Portsmouth raised £11,570 to build two Spitfires.

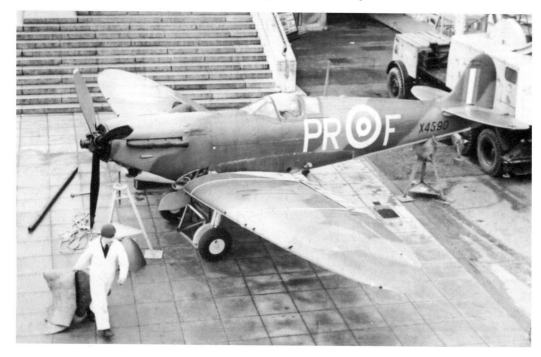